Cartoon 360°

Secrets to Drawing Cartoon People and Poses in 3-D

Harry Hamernik

About the Author

Harold "Harry" Hamernik is a freelance artist based in San Diego, California, whose portfolio includes graphic design, web design, illustrations, caricatures, charcoal drawings and oil paintings.

Harry holds a BA in Advertising and Graphic Design from The Advertising Arts College. His Masters in Education in Instructional Leadership is from Argosy University. Additionally, Hamernik has received training in traditional art at the Watts Atelier of the Arts and the Los Angeles Art Academy.

Currently, Harry teaches in the Media Arts and Animation department at the Art Institute of California–San Diego and in the UCSD extension program at the Digital Arts Center. Additionally, he teaches a variety of one-day workshops and art classes throughout southern California.

See more of Harry Hamernik's work on the Web at www.hhportfolio.com.

Cartoon 360˚. Copyright © 2010 by Harold Hamernik. Manufactured in China. All rights reserved. No part of this book may be reproduced in any form or by any electronic or mechanical means including information storage and retrieval systems without permission in writing from the publisher, except by a reviewer who may quote brief passages in a review. Published by IMPACT Books, an imprint of F+W Media, Inc., 4700 East Galbraith Road, Cincinnati, Ohio, 45236. (800) 289-0963. First Edition.

Other fine IMPACT Books are available from your favorite bookstore, art supply store or online supplier. Visit our website at www.fwmedia.com.

14 13 12 11 10 5 4 3 2 1

DISTRIBUTED IN CANADA BY FRASER DIRECT
100 Armstrong Avenue
Georgetown, ON, Canada L7G 5S4
Tel: (905) 877-4411

DISTRIBUTED IN THE U.K AND EUROPE BY F+W MEDIA INTERNATIONAL
Brunel House, Newton Abbot, Devon, TQ12 4PU, England
Tel: (+44) 1626 323200, Fax: (+44) 1626 323319
Email: postmaster@davidandcharles.co.uk

DISTRIBUTED IN AUSTRALIA BY CAPRICORN LINK
P.O. Box 704, S. Windsor NSW, 2756 Australia
Tel: (02) 4577-3555

Library of Congress Cataloging-in-Publication Data
Hamernik, Harry, 1973-
 Secrets to drawing cartoon : people & poses in 3-D / Harry Hamernik. -- 1st ed.
 p. cm.
 Includes bibliographical references and index.
 ISBN 978-1-60061-913-7 (pbk. : alk. paper)
 1. Human beings--Caricatures and cartoons. 2. Figure drawing--Technique. 3. Cartooning--Technique. I. Title.
 NC1764.8.H84H36 2010
 741.5'1--dc22
 2010022902

Edited by Kelly Messerly and Amy Jeynes
Production Edited by Christina Richards
Designed by Guy Kelly
Production coordinated by Mark Griffin

Acknowledgments

I would like to acknowledge the Art Institute of California–San Diego for awarding me the Winter 2009 Sabbatical, which allowed me to complete this book. I would also like to acknowledge Pam Wissman, Editorial Director at IMPACT Books, for giving me the opportunity to write a third book. Thank you to editors Kelly Messerly, who was patient with me for the entire process, and Amy Jeynes, who helped wrap this project up. Last, thanks to my kids, Josie and Silas, who helped Daddy finish all the drawings.

Dedication

This book is dedicated to my beautiful wife, Kate. All the success I've had and will have is a result of your love and support. I Love You.

Metric Conversion Chart

To convert	to	multiply by
Inches	Centimeters	2.54
Centimeters	Inches	0.4
Feet	Centimeters	30.5
Centimeters	Feet	0.03
Yards	Meters	0.9
Meters	Yards	1.1

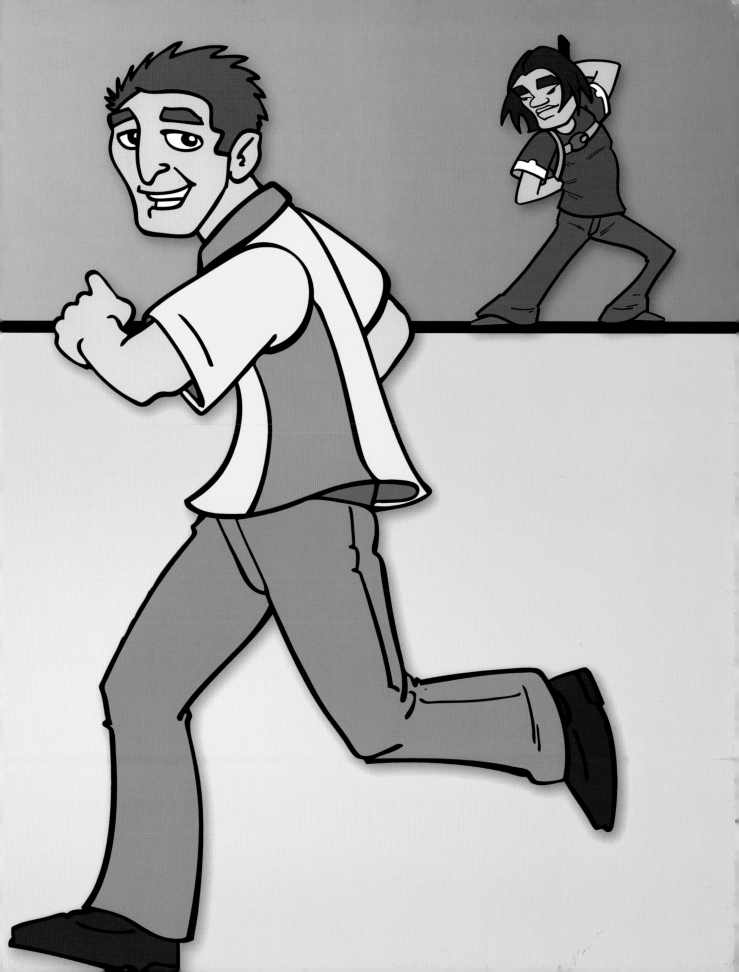

contents

Introduction

This book is for anyone who draws cartoons and anyone who wants to. That's a lot of people. This book will help anyone draw cartoons or draw them better:

- Novices can learn the secrets of cartooning from the ground up using my step-by-step approach.
- Amateurs can use the character design fundamentals taught in this book to overcome learning plateaus.
- Professionals can use the steps as a way to break out of their creative routines and expand their drawing horizons.

My method for drawing, constructing and finishing cartoons works with any drawing style. Plus, my method helps ensure that all mistakes are corrected before you begin the final art, making cartooning faster and more fun.

Enjoy drawing!

—Harry Hamernik

Why 3-D?

- Have you tried cartooning but been dissatisfied with the results?

- Have you ever drawn a great cartoon only to find that you could not draw the same character again to save your life?

My 3-D drawing method solves those problems. Read this book and work the lessons in order, from start to finish. With practice, you will be able to design great cartoon characters and draw them again and again from any angle and in any pose you want.

Resources

- For tutorials, more art examples, and recommendations for artists, check out my blog: http://tutorialsbyharry.blogspot.com

- Check out my other books, *Face Off* and *Cartoonimals*.

- Join my Facebook group and post your drawings from any of my books! Just put "Face Off Comic Portraits" into the Facebook search box.

Materials

Simple materials are all you need for drawing cartoons. Anything you don't already have, you can get at your local art supply store or online.

Portable Light Table

A light table is essential for constructing cartoon characters. It may take five to ten drawings to complete one inked, colored cartoon. Tracing lets you keep the good lines from the previous drawing so that you are not introducing new drawing errors with every step.

Ruler

You'll need a ruler for measuring and for marking straight lines when constructing cartoon heads and bodies.

Circle Template

I have used circle templates throughout this book to draw accurate circles. Cartoon heads always start with a circle, and body height is measured in head circles, so accurate circles are important.

Pencils

I like to sketch in blue colored pencil. Then I use a regular no. 2 pencil to darken the lines I want to trace.

If you want to sketch with colored pencil, choose a type that erases well. I use Col-Erase colored pencils by Prismacolor.

ESSENTIAL TOOLS
A portable light table, ruler and circle template are indispensable for constructing cartoon characters.

Why Trace?

Professional cartoonists trace for the sake of speed and accuracy. If you draw every stage of a cartoon from scratch, you will be introducing new errors at the same time you are trying to fix old ones.

For darkening my lines, I use Ticonderoga Tri-Write pencils, but you can use any brand you like.

For coloring finished art, any brand or type of colored pencil is fine.

Eraser and Pencil Sharpener

You'll also need an eraser (any kind) and a pencil sharpener. Electric or battery-operated pencil sharpeners work best. If you buy a manual one, get the best one you can find.

Markers or Pens for Inking

Try a variety of round-tipped pens and markers:

Soft-nib markers produce a line that can vary from thin to thick depending on how much pressure you use. Look for this type of marker at your local art supply store or online.

Fine-tip pens (such as felt pens, fine-tip permanent markers, and technical pens) work well for inking fine details and small drawings.

COLORED PENCILS
Erasable colored pencils are great for sketching. For coloring finished art-work, any type of colored pencil is fine.

PENCILS AND MARKERS
Use any type of no. 2 pencil to darken sketched lines to make them easier to trace.

For inking, try a variety of fine and thick pens and soft-nib mark-ers. Soft-nib markers produce great line quality and are ideal for larger drawings. Fine pens work well for inking smaller drawings and fine details.

STAGE 1:
Idea Sketches

The first step in cartooning is to sketch ideas. You can use a sketchbook or copier paper. I like to sketch with a blue colored pencil, as is done in the animation industry, but any pencil is fine.

To capture a lot of ideas quickly, sketch fast—no more than one or two minutes on each character—and do not erase. Resist the temptation to slow down. Aim to fill the page with heads in about ten minutes.

Secrets of Fast Sketching

- Work fast: One or two minutes per head.

- Don't erase.

- Don't slow down to rework any one head until you've filled the page with quickly sketched heads.

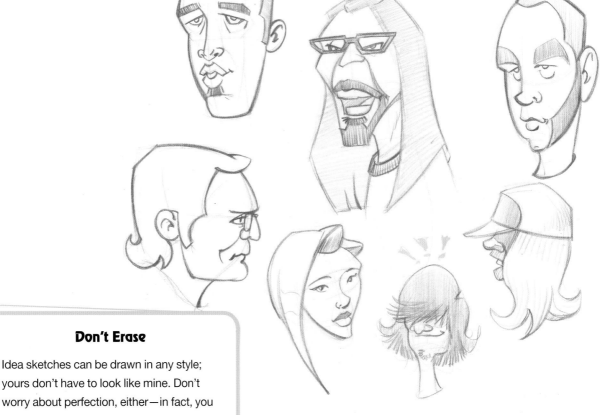

Don't Erase

Idea sketches can be drawn in any style; yours don't have to look like mine. Don't worry about perfection, either—in fact, you *shouldn't* use an eraser at this stage.

Brainstorming With Sketches

During the idea stage, challenge yourself to draw cartoons that are very different from each other. Follow me through my sketchbook to see how I make variations.

Ways to Vary Your Sketches

- Try drawing different hair colors, ages, ethnicities and face shapes.

- Choose one head you've drawn, then try to draw one that's "opposite" in every possible way.

- Draw two characters interacting.

- Take one feature you like and use it again, but on a very different character.

- Sketch quickly to get many ideas in a short time.

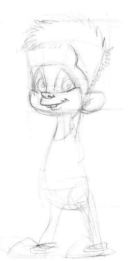

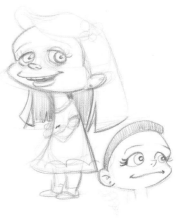

1 I start with this sketch. Not shown is a whole page of characters I drew before this, which I tossed away because they were terrible! But that's OK; I'm working fast, so that first page was only about ten minutes' worth of drawing.

2 Notice I am drawing mainly heads at this point. The head is the most important part of a character. Once you have a good head sketch, the body will follow naturally.

3 When you like a character, you may be tempted to slow down and start adding more detail to it, as I did with this girl. Resist that temptation. My rule when I'm sketching is: No slowing down to add details until the page is filled with fast sketches.

Try Caricature

Drawing caricatures is a great way to learn what makes each person different from the next. To learn how, check out my book *Face Off: How to Draw Amazing Caricatures & Comic Portraits*.

4 Once you get your creative juices going, you will find that it gets easier to draw quickly.

Here, I was trying out a variety of hair colors and face shapes. But I drew all the faces at the same angle, what's called a 3/4 view. Using the same angle every time helps you sketch faster.

CARTOONING TERM:
3/4 VIEW

In 3/4 view, the subject is turned halfway between front view and a side view.

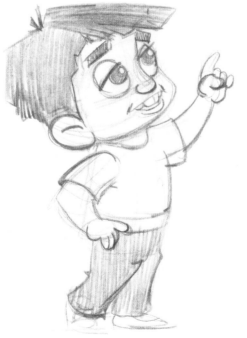

5 Challenge yourself to create even greater variety by sketching an opposite version of one of your characters. This sketch is my attempt to make a character as different as possible from the boy in the previous sketch. Notice all the opportunities to "reverse" a character:

- Hair: dark and combed down vs. light and flipped up

- Nose: long and angled downward vs. short and pointing forward

- Eyes: dark with heavy lids vs. light with narrow lids

- Smile: toothy vs. lips only

6 Keep changing things up. Try drawing two characters together; try different hair colors, hair textures, body weights and face shapes.

7 Take one part of a character and use it again in a different character. Here, I took the curly pouf hair from the stout boy in the previous sketch and tried it on a suave, muscular adult.

8 This was the final sketch on my page. Take your time. Don't rush just because you have a good idea you can't wait to develop. Give each drawing a chance, and you will have a great page full of good ideas.

Head Construction

More than any other feature, the head makes the cartoon character. Take time to study faces to find out what makes people different from each other. We all have the same features; the shapes, spacing and placing of those features are what distinguishes one person from another.

At the end of the section are tips for drawing specific features such as eyes, noses and mouths. But don't jump ahead yet. First you need to know how to construct heads.

> **CARTOONING TERM:**
>
> ## CONSTRUCTION
>
> Construction is the process of marking off proportions in a drawing using one shape as the unit of measurement for all the other shapes and relationships in the drawing.

Method 1: Feature Spacing

First, let's use feature spacing to construct a head that has realistic proportions.

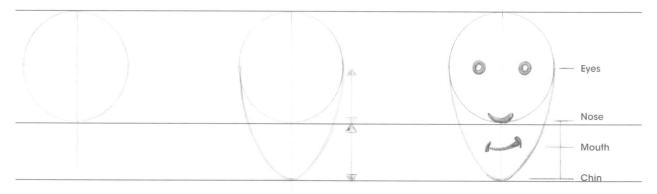

1 Start with a circle representing the cranium. Divide the circle in half both ways (horizontal and vertical).

2 Measure the height of your circle. Then measure one-half that height from the bottom of the circle and make a mark. Create the jaw by connecting the sides of the circle to the mark. This head is now a realistic-looking 1½ circles tall.

3 The eyes for a realistic face go on the horizontal centerline of the circle about halfway from the center to each edge. The nose goes at the bottom of the circle. The mouth goes halfway between the nose and chin.

Comic Feature Spacing

Changing the feature spacing away from realistic proportions is how you begin to create a comic character. Different feature spacing results in different character types.

Tip

If you have trouble making your cartoon characters look different from each other, feature spacing will help you a lot.

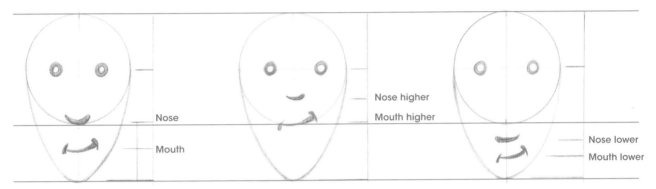

1 Here's the realistic head from the previous page for comparison.

2 Draw another head 1½ circles high. This time, put the mouth where the nose was, then put the nose in between the mouth and the eyes. This creates a character with a short nose and a large chin.

3 Draw another head 1½ circles high. Place the nose lower than the standard location. This creates a character with a long nose and little to no chin. (With less space available for the mouth, you wouldn't be able to give this character large, full lips.)

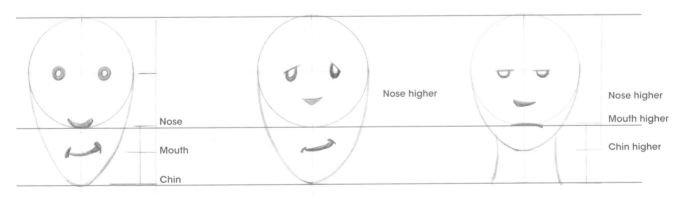

1 Here's the realistic head again to make it easier to compare.

2 Draw another head 1½ circles high. Place the nose up from its normal position without changing the location of the mouth. There are endless possibilities with the feature spacing approach to head design.

3 You can also change the location of the chin. I placed the chin where the mouth should be, making this head 1¼ circles high instead of 1½. The nose is moved up accordingly. Where the chin would be on a realistic face is now where the shirt collar will start.

Feature Spacing in 3-D (3/4 View)

Turning the head 45 degrees, or halfway between front and side view, produces what is called a 3/4 view, the view we will draw in for the rest of this book.

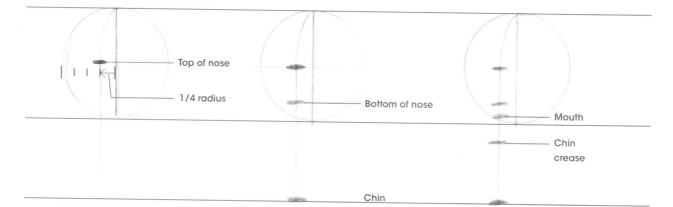

1 Draw the head circle and divide it in half both ways. Add a centerline for the face as shown.

Mark the location of the nose where the centerline of the face crosses the horizontal centerline.

2 Mark the location of the chin next to create a final head height (in this case, 1¾ head circles high). With the chin in place, add a mark for the bottom of the nose.

3 Add marks for the mouth and the chin crease. (Everyone has a chin crease, so you can add that feature if you want to attract attention to that part of the face, or omit it if you don't.)

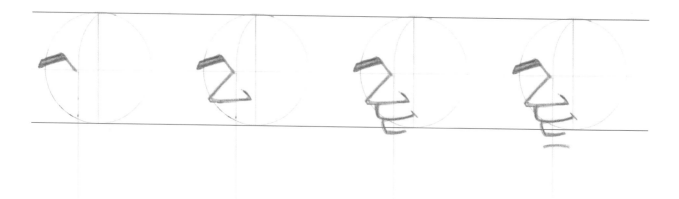

4 Now draw the ridge of the far brow ridge. Do not connect this line to the centerline; see the sidebar on page 15 to learn why.

5 Add the nose. It starts at the end of the brow line, which is near (not on) the centerline.

6 Starting at the bottom edge of the nose, add the silhouette of the mouth muzzle and the mouth line itself. Finish with the lower lip.

7 Add the chin crease.

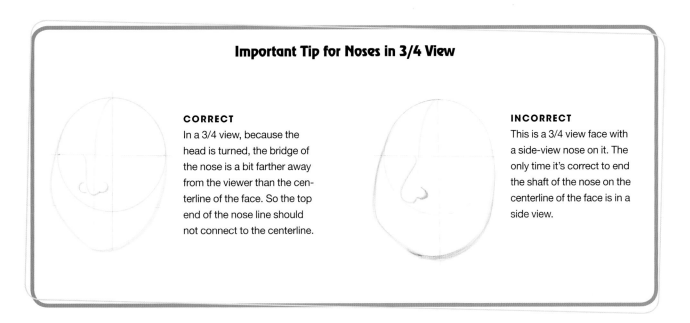

Important Tip for Noses in 3/4 View

CORRECT

In a 3/4 view, because the head is turned, the bridge of the nose is a bit farther away from the viewer than the centerline of the face. So the top end of the nose line should not connect to the centerline.

INCORRECT

This is a 3/4 view face with a side-view nose on it. The only time it's correct to end the shaft of the nose on the centerline of the face is in a side view.

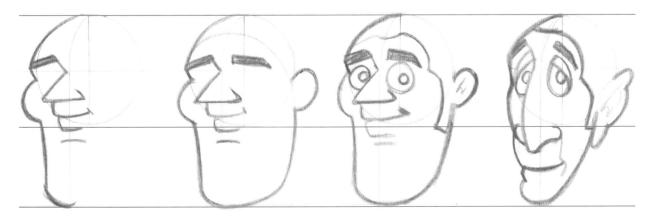

8 Begin adding the silhouette or outline of the far side of the face, starting at the top of the centerline and continuing with brow, cheek, jaw and chin. (The face silhouette will be explained further in the next demonstration.)

9 Complete the face silhouette with the near jawline and ear, ending where the ear meets the head.

Add the other eyebrow.

10 Add details. This includes eyes, hair and other facial lines. The far eye may be slightly behind the nose.

11 This step shows you that if you change the feature shapes and the feature spacing and placing, you always get a different-looking character.

Method 2: Feature Shapes

In the "feature shapes" method of head construction, you rough in the features using shapes. Let's try it by drawing three very different heads in a 3/4 view.

Help for Eyes, Noses and Mouths

I will have tips for drawing facial features later in this section (pages 24–31). If you flip ahead to peek, be sure to come back to this page; you'll learn the most by reading this book sequentially from beginning to end.

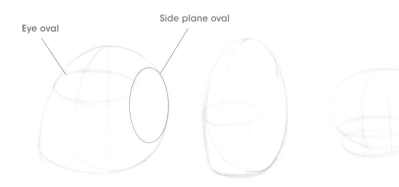

Eye oval

Side plane oval

1 Start drawing the three heads as follows:

- Draw three distinctly different head shapes.
- Add a face centerline (explained on page 14) to each head.
- Add an eye oval to each head.
- Add a side plane oval to each head representing the near side of the head.

2 Finish the eyes on all three characters first, using simple ovals and curves. Try to make the eyes as different as you can for each character: for example, if you reuse an eye shape, vary the size.

After the eyes, add noses, mouths and ears in the same manner: Work one feature at a time and aim for maximum variety.

3 Trace onto a clean sheet of paper to make a final drawing, then add details and hair.

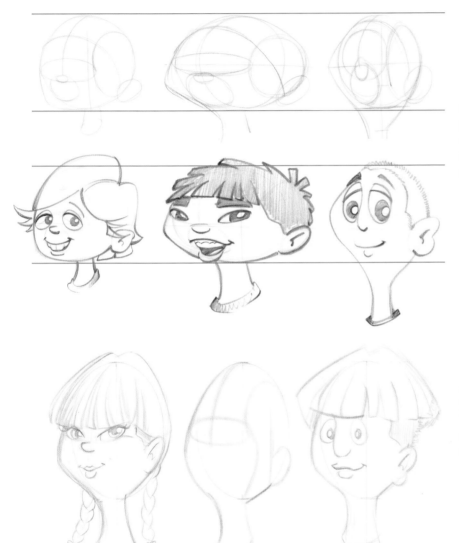

USE FEATURE SHAPES TO CREATE VARIETY

Here, I've constructed three heads starting with the same head circle for each. This shows that you can achieve a wide variety of characters just by varying the feature shapes.

ANOTHER EXAMPLE OF VARIETY THROUGH FEATURE SHAPES

These two cartoon girls have the same head shape (center) and the same feature placement. The difference is the feature shapes.

ACCURACY IS KEY

Drawing the same character more than once requires careful construction. If you're off even a little with your feature spacing or placing, you will end up with an entirely different character, as you can see here.

First drawing; note feature spacing/placing

Same spacing, different placement

Similar placement, different spacing

Turning the Head

Placing features on a turned head is one of the most important lessons in this book.

To start, think about how the neck moves the head. The neck can:

- Rotate the head left or right.
- Tip the head up or down.
- Tilt the head left or right.

Let's learn how to draw the head in each of those positions. Use a circle template to draw the circles.

Rotate (Left or Right)

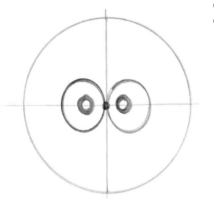

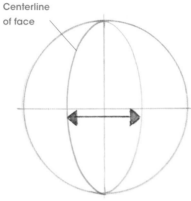

Centerline of face

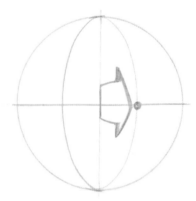

1 Draw the head circle and divide it in half both ways. In a front view, the vertical centerline of the circle is also the centerline of the face. Add some simple oval eyes that touch the centerline.

2 To draw new centerlines for a rotated head, draw identical curves to the left and right of the original centerline and the same distance away from it.

3 Choose one side or the other to be the new location of the center of the face.
(The curve you don't choose becomes the centerline for the side of the head. Where that line crosses the horizontal centerline is where the ear is located on realistic human heads.)

> ### FYI for Aspiring Animators
>
> The topic of head turns is only briefly introduced on these two pages. This is all the information most readers will need. However, if you are planning to do animation, seek out books and tutorials to learn more.

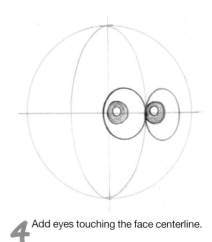

4 Add eyes touching the face centerline.

Tip (Up or Down)

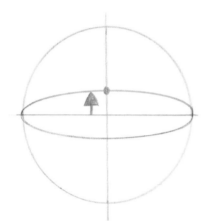

HOW TO TIP THE HEAD UP OR DOWN

Draw a new circle and divide it in half both ways. To turn the head straight up or down, draw the face centerlines from side to side instead of top to bottom. The arrow shows where the center of the head is now, meaning this face is looking up.

Try adding the eyes. (Hint: they touch the dot.)

Tilt (Left or Right)

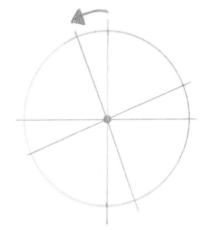

HOW TO TILT THE HEAD LEFT OR RIGHT

Draw another circle and divide it in half both ways. To tilt the head to one side, tilt the centerline. If this is a front view, the centerline remains a straight line.

Try drawing the eyes on this head.

Rotated, Tipped and Tilted

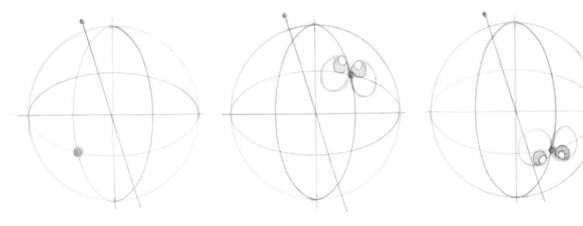

HOW TO ROTATE, TIP AND TURN THE HEAD

This set of drawings shows you a head that is rotated, tipped and tilted all at the same time. The circles, lines and ovals are exactly the same in each drawing. The ovals intersect in four places; you simply place the eyes at one of the four intersections.

See if you can draw the third and fourth possible locations for the eyes on this head.

The Turn-Around Chart

Drawing a turn-around chart is key to being able to draw the same character over and over.

Start Here

Front view 3/4 view Side view

1 Trace your 3/4 view head circle from page 14 at the center of a sheet of paper.

Use a ruler to draw horizontal lines across the paper marking the top and bottom of the head.

2 To the left side, draw the same head in a front view. Keep the shapes similar and placed correctly.

For the front-view face outline, you can usually copy the curve of the far side from the 3/4 view and use it for one side of the front view, then mirror that curve for the other side.

The line that goes from the ear to the forehead is the hair line.

The circle around the mouth area is called the muzzle.

3 On the right side of the paper, draw the profile or side view. The human head looks very different when you compare front view to side view. Use the same jaw line if possible. The muzzle (the mouth area) pops out from the face.

Tip

On a turnaround chart, it's important to draw the three head views all in a row. Use larger paper if you need to.

Reality Can Be Simplified

Notice the shapes for the hair, eyes, ears and nose are very similar in all three views. That does not follow the rules of realism, but it works because cartoon characters are recognized by their shapes.

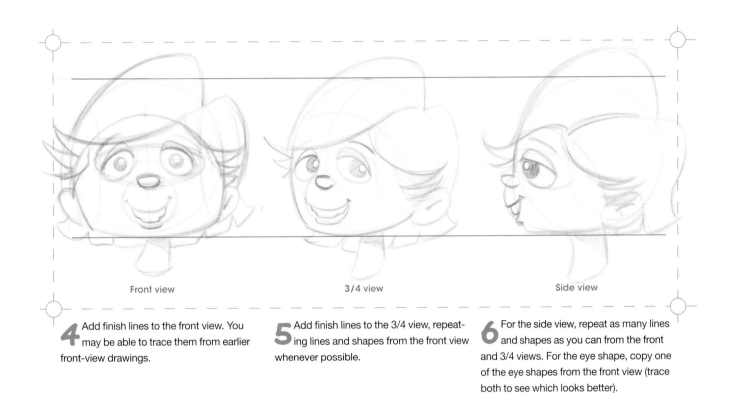

Front view 3/4 view Side view

4 Add finish lines to the front view. You may be able to trace them from earlier front-view drawings.

5 Add finish lines to the 3/4 view, repeating lines and shapes from the front view whenever possible.

6 For the side view, repeat as many lines and shapes as you can from the front and 3/4 views. For the eye shape, copy one of the eye shapes from the front view (trace both to see which looks better).

Doing Idea Sketches As Turn-Arounds

As you gain in skill and speed, you might enjoy doing your idea sketches (stage 1) in the form of turn-around charts. Expect to make mistakes and changes along the way. This girl changed quite a bit from my original idea sketch to the finished construction.

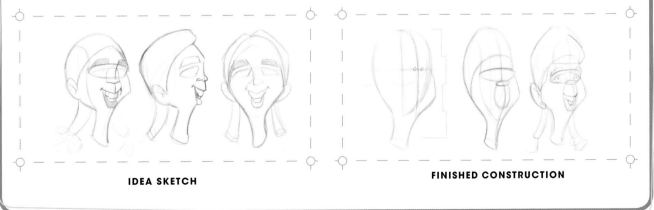

IDEA SKETCH **FINISHED CONSTRUCTION**

Evolution of a Turn-Around

Sometimes the final cartoon is not quite the same as your idea. This is OK. More often than not, your cartoon idea improves with the process.

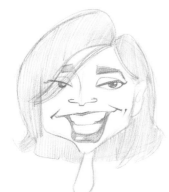

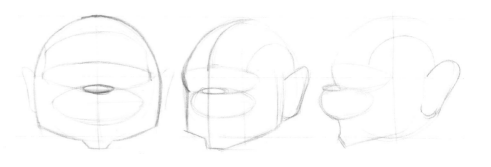

1 Here is an idea from my sketchbook. It's loose and sloppy, but has a good appeal.

2 I start the head design process with a rough, experimental turn-around (not shown) in which each view has slightly different proportions. I choose the look I like best, then redraw the entire turn-around chart to match.

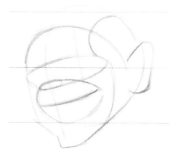

3 Based on the chart, I construct the final pose.

4 I add feature shapes next.

5 I draw the final artwork on a clean sheet of paper.

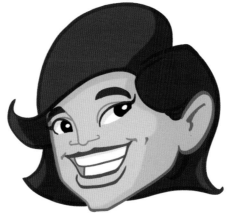

6 I ink and color. The final version is much better than my original sketchbook idea. Inking and coloring will be taught in stages 4 and 5.

Repeat Shapes to Create a Style

When you draw a cartoon, you're simplifying reality, so you can choose the sorts of shapes and lines you use. Will the shapes be spheres, boxes or pyramids? Will the lines be curved or angled? Make some choices, then repeat shapes and lines throughout your cartoon. Those choices are called design language.

Many artists call their design language their "style." A good artist can draw in many styles depending on the mood he or she wants to communicate.

CARTOONING TERM:
DESIGN LANGUAGE

The repetition of certain shapes and lines in a cartoon is called design language. Design language does a lot for a cartoon: it creates the overall art style, supports the mood, and helps your characters look as if they belong together in the same show or series.

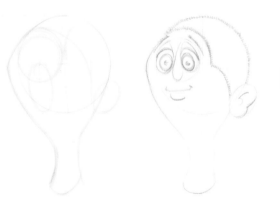 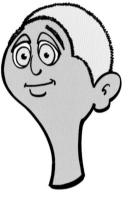

CURVED LINES ON ROUND SHAPES
This boy is made up of curved lines on top of spherical shapes. What mood do you get from this style?

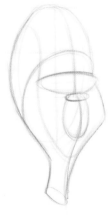 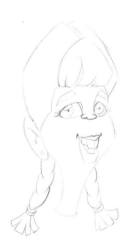

CURVED LINES ON TRIANGULAR SHAPES
This girl is made up of curved lines on top of triangular shapes. Does she look older or younger than the boy above? Which style would you choose for a cartoon with an edgy storyline?

23

Eyes

Eye Shapes

When I talk about a triangular or square eye, I am referring to the number of sides. The shape does not need to be geometrically correct.

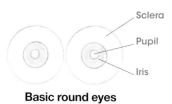

Basic round eyes

Oval eyes

Square eyes

Round eyes, irises to inside

Triangular eyes

Eye Colors

Plan for eye color when drawing. Light eye colors show up better when more iris area is visible. Dark eyes can have less iris and more pupil.

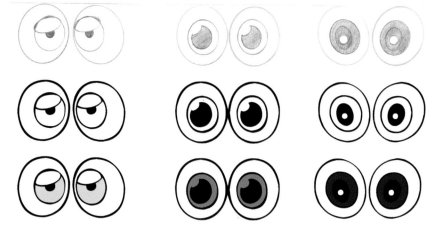

Light **Medium** **Dark**

Eyelids

If eyelids are small, you can leave them out.

Thin lids, angled down　　**Thick lids, angled up**

Eyelashes

Eyelashes make any type of eye look feminine.

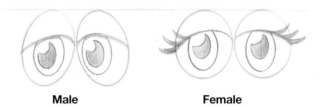

Male　　　　**Female**

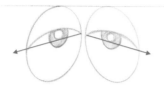

Eye Bags

In the language of cartoons, eye bags always mean "I'm tired." If the character isn't tired, do not draw eye bags.

Expressions

The amount of iris you leave visible has a big impact on the expression.

Neutral expression　　**Surprised or shocked**　　**Sleepy or annoyed**

Eye Spacing

The space between the eyes is measured in eye widths. Simple measurements such as ½, 1, or 1½ are easier to draw.

Eyes touching

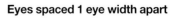

Eyes spaced 1 eye width apart

Eye Angles

Draw an arc to aid in matching the left and right eye angles. If you have trouble drawing the arcs freehand, curve templates called French curves are available at your local art store or online.

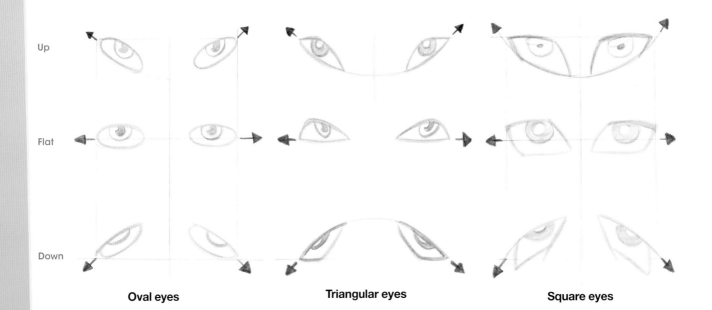

Up

Flat

Down

Oval eyes **Triangular eyes** **Square eyes**

Eye Placement

During construction, decide where the eyes will be in relation to the centerlines. Simple schemes are easier to remember and repeat.

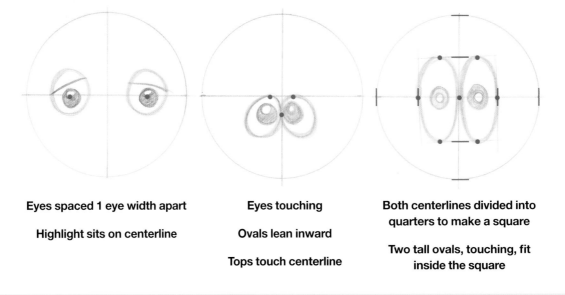

Eyes spaced 1 eye width apart

Highlight sits on centerline

Eyes touching

Ovals lean inward

Tops touch centerline

Both centerlines divided into quarters to make a square

Two tall ovals, touching, fit inside the square

Eye Exam

For each head, identify:

- Eye shape (round, oval, square, triangular)
- Eye spacing (number of eye widths)
- Eye placement (in relation to the centerlines)
- Eye angle (up, flat or down)

For an extra challenge, identify:

- Head rotation (looking left, right or straight ahead)
- Head elevation (looking up, down or straight ahead)
- Head tilt (tilted left, tilted right or vertical)

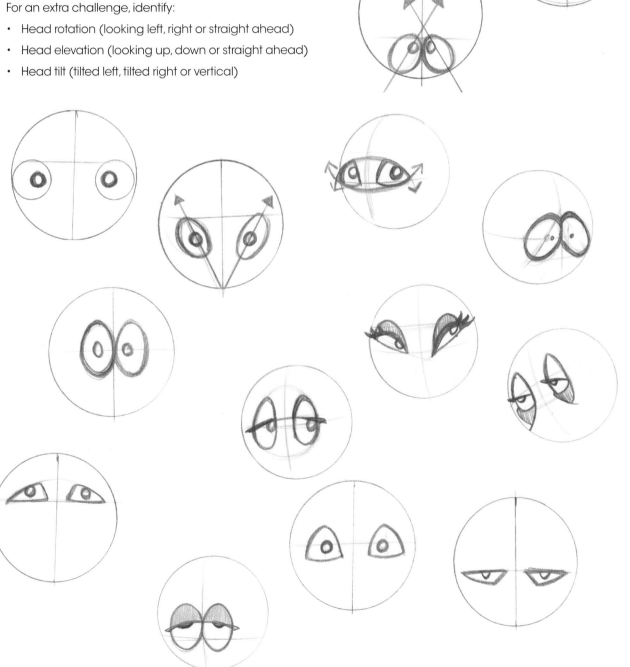

Noses

Planes of the Nose

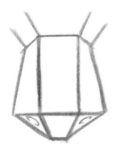

Simplified planes

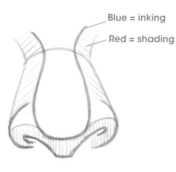

Blue = inking
Red = shading

Cartoon nose

Cartoon nose, inked/colored

Nostril Angles and Placement

Draw the nose shaft, then place the nostrils on it. They are separate structures.

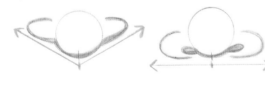

Up

Flat across

Down

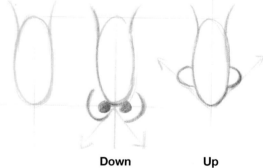

Down

Up

Lines for Noses

In 3/4 view, a bit of the far eye may be hidden behind the nose.

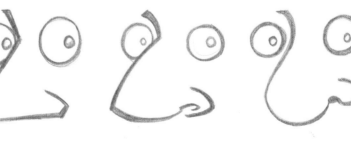

Straight

Double curve

Curve

Constructing the Nose With Lines

In 3/4 view, the top of the nose does not touch the face centerline (see page 15).

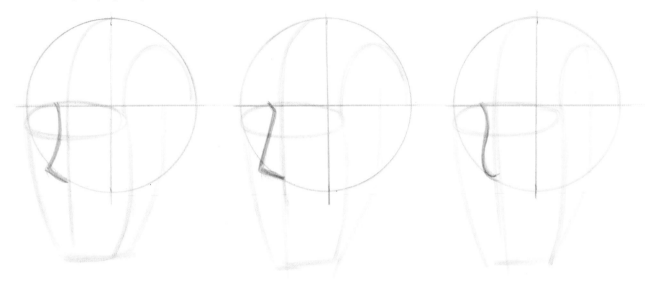

Curved line + straight line **All straight lines** **Double curve**

Constructing the Nose With Shapes

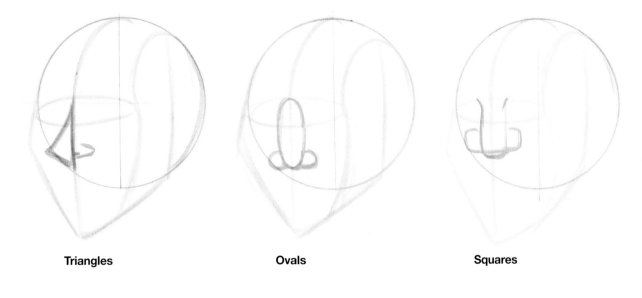

Triangles **Ovals** **Squares**

Mouths

Mouth Muzzle

The mouth muzzle is a circle that goes from the top of the nostrils to the chin crease. Divide the muzzle circle into thirds to locate the mouth opening on a realistic face.

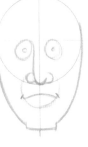

Top of nose

Bottom of nose

Mouth muzzle divided into thirds

Mouth

Chin crease

Upper Mouth Line

For the upper mouth line, use one of three angles: up, flat or down.

| Up | Flat | Down |

Lower Mouth Line

For the lower mouth line, approximate one of three letter shapes: U, V or W.

| U | V | W |

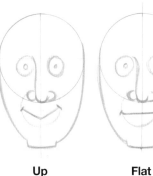

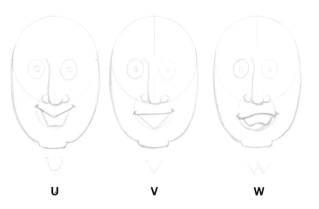

Simpler Is Faster

Three choices is plenty for each feature shape, line and angle. When you limit your choices in this way, your drawings will get better faster.

1 Angle + 1 Letter = Mouth

To draw the mouth, choose one angle (for the top line) and one letter shape (for the bottom line) and put them together.

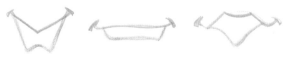

Teeth, Lips and Chin

Draw details such as gums and tongue on some characters and not others for another level of detail.

Simple teeth

Detailed teeth

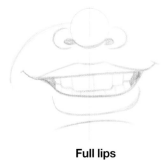

Full lips

Thin lips

Gums and tongue

Mouth Placement and Chin Shape

Try several combinations of mouth shape, mouth placement and chin shape for each character before deciding which you like best.

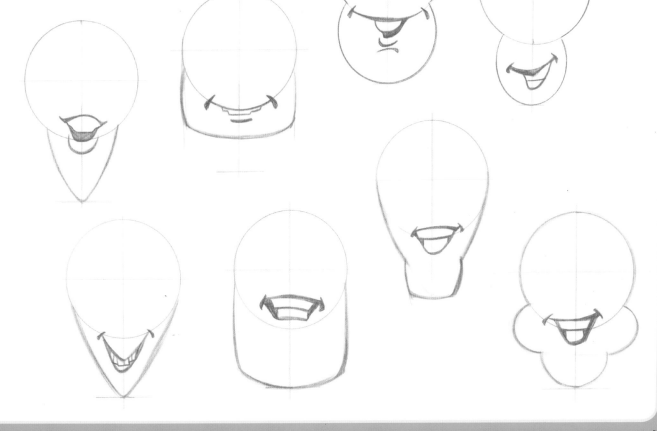

Adding a Body

So far, you've sketched ideas for cartoon heads (stage 1), and you've taken some of your favorite ideas through the construction stage using feature spacing and feature shapes (stage 2).

Now you will learn how to add a body—which is relatively easy to do, once you have a head drawn. I will show you how to test different head/body proportions, sketch pose ideas using outline-type stick figures, and then unite head and body into a drawing that's free of errors and ready for inking and coloring.

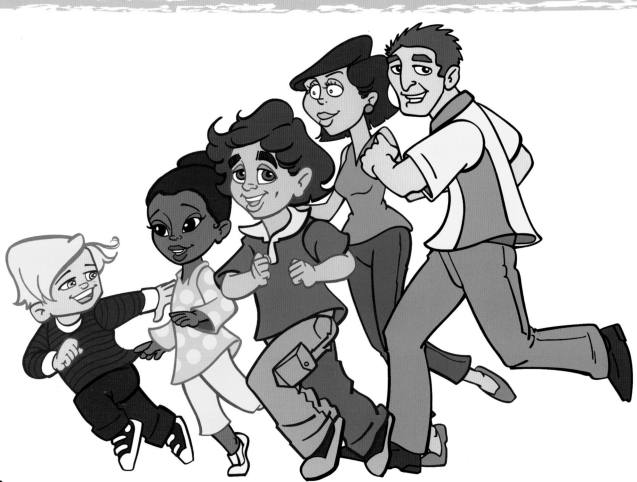

Test Body Proportions Using Stick Figures

To try out different body proportions, we will use outline-type stick figures, which consist of:

- A head shape
- A torso shape
- A waist line
- Stick legs
- Simple feet shapes

Arms are not needed at this stage.

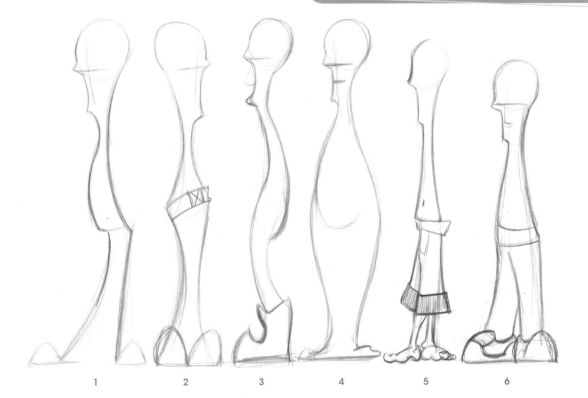

1 2 3 4 5 6

1 From your prior sketches, choose a head you like. Draw that head shape in 3/4 view. Add an outline-style stick figure body in a simple standing pose.

2 Right next to the first stick figure, draw a head of the same shape and at the same height as the first one, but in the opposite-facing 3/4 view. Add a stick body with a different body shape and waist height.

3 Draw a third head (same shape), starting the top of the head at the same height as the first two, but make this head smaller and in profile view.
Add a body, changing the body shape and waist height yet again. Variety is the key.

4 Draw a fourth variation, using the smaller head from step 3 but with a different body shape and waist height.

5 Draw a fifth stick figure that is shorter than the others, again using the smaller head from step 3 and changing body shape and waist height.

6 Keep adding stick figures with different proportions and body shapes until you find one you like.

Decide Final Head Height

When you add a body to a head, you need to decide how large to make the body in relation to the head. This proportion is described with a measurement called head height.

The distance from the top of the head to the bottom of the chin is one head height. Imagine a cartoon character standing next to a stack of heads (his own). That's how head height is measured.

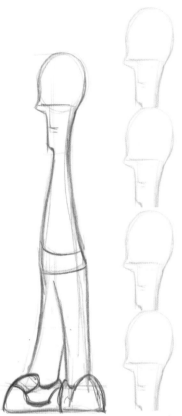

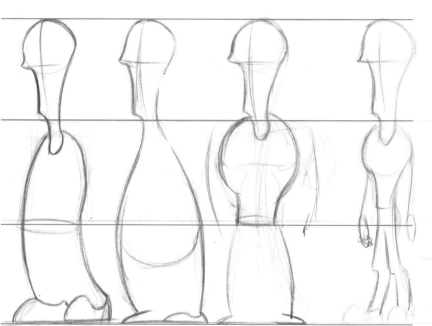

1 Look at the sketches you did on the previous page. Choose the figure whose proportions you like best. (I chose number 6.)

Use a ruler to measure your chosen figure's head height, then mark off head heights from the ground up to determine your figure's head height.

Mine was about 3½ heads tall, as you can see here.

2 On a fresh sheet of paper, use a ruler to mark horizontal lines across the page representing your chosen number of head heights. Now draw three to five figures with the same head height but different body types.

I decided that my character felt a little too tall and skinny at 3½ heads, so I tried some variations at 3 heads tall.

Stretch Yourself

Many artists tend to use the same body shape over and over. By forcing yourself to test several body shapes for every cartoon you draw, you are training your hand and brain to see new shapes. This expands your possibilities for future cartoon characters.

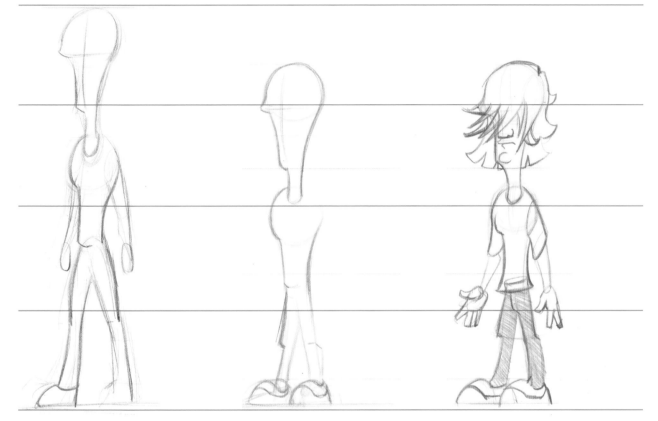

3 From step 2, choose the body type you like best, then try that body type with a different head height. I tried my character at 4 heads tall instead of 3.

4 Decide on the final head height for your character. Redraw the head shape, measure off the head heights and draw the figure once more.

For my character, I decided that a head height of 3½ heads would work best with this body type.

5 Now add details. At this stage, try to include all the lines that will be on the final cartoon character.

I prefer drawing the head, shoulders and waist first. Then I draw the legs and feet. The last parts are the arms and hands.

Keep Head Heights Simple

When choosing a head height for a character, stick to whole heads or increments of ½ or maybe ¼. Increments smaller than ¼ will be too difficult to draw.

Guitar Dude

You have a head design you like (stage 2), and you've decided on a final head height and body shape for your character (pages 34–35).

Now I'll show you how to take that information and turn it into a pose. Each "Design a Pose" demonstration will result in a drawing that's ready for inking (stage 4) and coloring (stage 5).

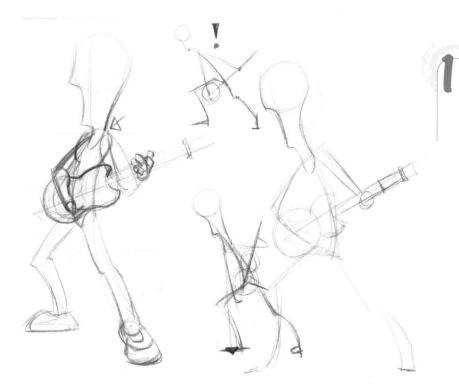

1
Draw twenty or more stick figures, testing different pose ideas for your character. I gave this one a guitar and drew him in some classic guitar-player poses.

You can use photos or even video as reference for an action you are trying to draw. Just remember you can't do a straight copy of someone else's image without permission.

2
Choose the pose you like best from step 1. This is the pose you'll develop into a final drawing.

With your ruler, lightly draw a baseline on your paper and mark off the number of head heights you determined when you designed this character (pages 34–35).

Draw the head. (If the legs are bent, the top of the head should be a little below the actual head height.)

Rough in the pose using simple circles and rectangles. This torso is based on a circle, but torsos can also be rectangles. Arms and legs can be sticks or rectangles.

Sketch and adjust until the proportions are correct, then darken the final lines.

Counterbalance Your Poses

Include a shoulder line and a waist line in every stick figure you draw. Then you can use those lines to mimic the way real bodies counterbalance themselves as they twist and move. For example, if the right shoulder is forward, the left hip should be back; if the left arm extends back, the right leg should extend forward. This tip will give your poses more movement and attitude.

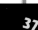

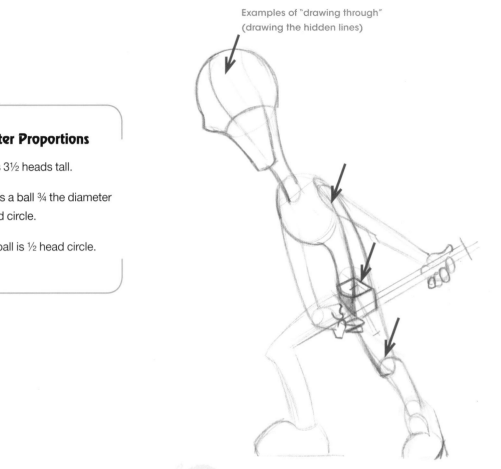

Examples of "drawing through"
(drawing the hidden lines)

Character Proportions

- This guy is 3½ heads tall.

- His chest is a ball ¾ the diameter of the head circle.

- His waist ball is ½ head circle.

3 Use your light table to trace the basic shapes and forms onto a new piece of paper. Now use the technique of "drawing through" (explained in the sidebar on this page) to make the flat shapes from step 2 into three-dimensional spheres and cubes. Arms and legs can be drawn as tubes (cylinders).

Pay special attention to where the arms and legs join the torso. Drawing through is especially helpful for this.

This drawing should include a shape representing the pelvis. This is an important shape to capture correctly because it connects the torso and the legs. In a dynamic pose like this one, the pelvis is tilted, and drawing that tilt correctly will help you draw the torso and legs correctly also.

CARTOONING TERM:
DRAWING THROUGH

"Drawing through" is a method for constructing 3-D objects. You pretend the object you're drawing is transparent, allowing you to see all the structural lines that are normally hidden. As you draw, instead of stopping a line where it disappears from view, you continue the line, drawing through the shapes in front of it.

When your sketch looks right, you don't have to erase the extra lines. Just darken the final lines and trace them onto a fresh sheet using your portable light table.

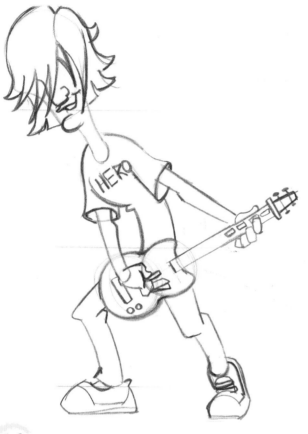

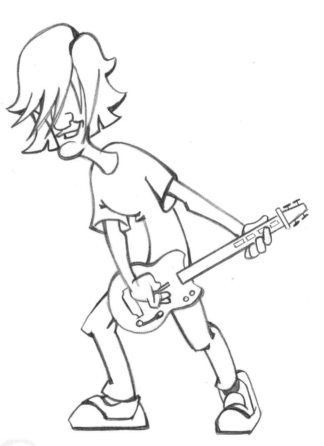

4 On a new sheet of paper, trace the final lines of your cartoon from the previous sketch with the help of your light table.

Evaluate your drawing. I liked the head I drew, but I didn't love its position in relation to the body. The neck looks too stiff and straight for this pose.

5 If you want to fix something, trace the correct lines onto another sheet of paper and redraw the problem part.

Here, I've corrected the position of the head. First I traced the body; then I rotated and shifted the paper slightly and traced the head where I wanted it.

Cute Girl

Now that you've tried the pose design process (pages 36-39), keep practicing it with new and varied characters!

Remember that every pose starts with:

- A head design (stage 2)
- A body shape (page 33)
- A head height measurement (pages 34–35).

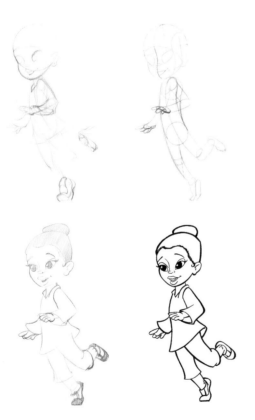

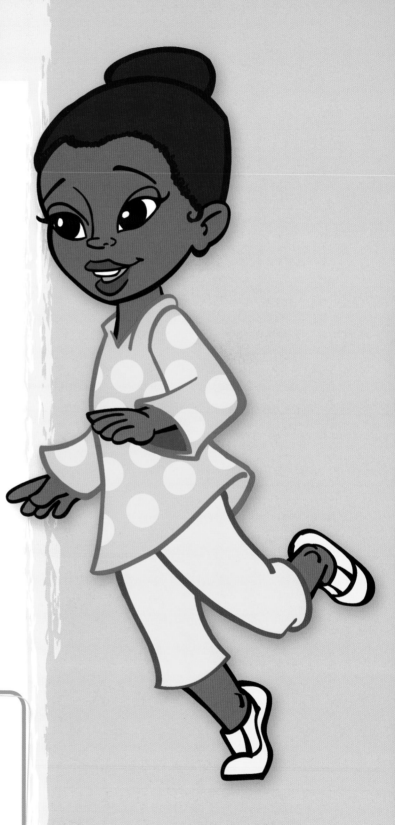

Proportions for Different Ages

- An adult cartoon character is 5–6 heads tall.

- Babies are 2–2 ½ heads tall.

- Kids and teens are in between; the taller a child's proportions, the older she will look.

 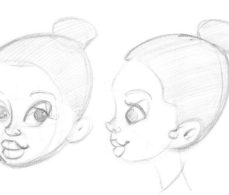

HEAD DESIGN

This girl started as a simple constructed head (left). When I added features, she really came alive for me.

FINISHED BODY CONSTRUCTION

This is my character design. You'll remember from pages 33–35 that character designs are done in a simple standing pose, and their purpose is to determine body shape and total head height.

—½H

Character Proportions

- This girl is 3 heads tall. One head height is from bottom of chin to top of the hair bun.

- Her waist ball is ½ head circle and centered at the bottom of the second head height.

- Three waist circles, stacked, create her body.

1 Draw twenty or more stick figures of different poses. Choose the one you like best, then start adding flat shapes (circles, rectangles).

As part of the pose design sketch, you can experiment with some details, as I was doing here with the shoes and the outline of a dress.

2 Trace the construction shapes onto a clean sheet of paper and use "drawing through" (page 38) to ensure the body is correctly put together. If there were any problems with the proportions in your stick figure, fix them at this stage. Here, you can see that I corrected the torso height (three waist balls, stacked).

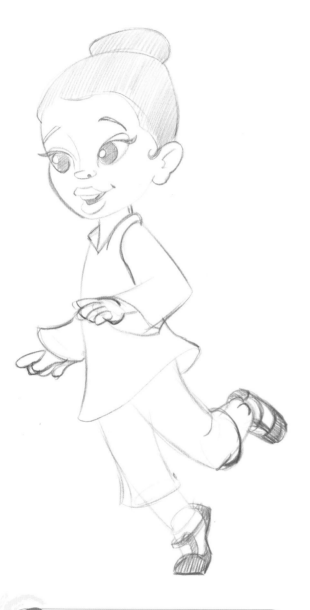

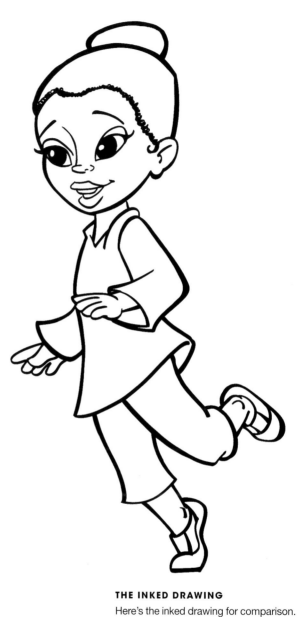

THE INKED DRAWING
Here's the inked drawing for comparison.
Inking will be taught in stage 4.

3 Trace the final lines onto a new sheet of paper. All lines that you would ink for the final cartoon should be present in this drawing, so details such as clothing should be added now.

Remember

Tracing lets you fix old errors without introducing new ones. If you're not happy with a drawing, trace the lines that worked onto a new sheet and redraw what you need to.

Soccer Mom

When you are comfortable with the character design process and the construction process, you may want to combine them. This is a sign that you are getting the idea behind this book.

Combine, Don't Skip

When you can do a cartoon in fewer steps, you're not actually skipping over any of the key stages (idea, head construction, body proportions, pose construction). You're just compressing them into fewer drawings by working two (sometimes even three) stages in each drawing.

Character Proportions

- This woman is 5 heads tall. (I didn't count her hair when measuring the head circle.)

- Her waist ball is 1 head circle and centered at the bottom of the fourth head height.

1 Sketch an idea for a character in a very basic pose. As you gain in skill and confidence, you'll be able to include more construction lines in your early sketches.

2 Use your light table to trace what's right about the proportions of your idea sketch, creating the beginnings of a construction sketch. Trace the head first, then use that to determine the final head height for the character.

Constructing With Blocks

I'm going to use a block to construct this character's upper body. Blocks take longer to draw than spheres, but they do define form a bit better. With a block shape, you can clearly see the sides of the shape and whether the shape is tilted.

3 With the help of your light box, do a new, more detailed sketch showing the pose and the external details, such as clothing.

4 Do a construction sketch to finalize the pose, making sure the proportions are right.

5 Trace the final lines onto a new sheet of paper, starting with the head and working down.

THE INKED DRAWING
Here's the inked drawing for comparison. Inking will be taught in stage 4.

Athletic Boy

This boy is running fast, and his feet are in midair. You can tell because he is leaning so far, he would fall over if his feet were planted on the ground.

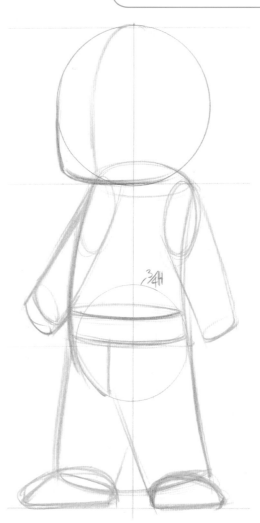

Character Proportions

- This boy is 3 heads tall.

- The waist ball is ¾ of a head circle tall and is centered at the bottom of the second head height.

1 Sketch out a cartoon character, including some construction lines and all the basic details of the final cartoon. Figure out his face and clothes.

2 On a new page, trace the construction shapes of your character. Adjust the height to make it a neat number of head heights.

3 Now that you know what your character looks like (from step 1) and what his proportions are (from step 2), you can pose him.

Sketch out a pose lightly using a stick figure. Then add the basic construction shapes, correcting the proportions as needed. Last, add surface details. This ends up being a messy drawing.

4 On a clean sheet, trace the construction lines. This step is very important; you cannot take chances by guessing at his proportions.

5 Trace the final details onto a new sheet, creating a cleaned-up drawing. Add more details if you like. You can even clean this drawing up again if you need to.

THE INKED DRAWING
Here's the inked drawing for comparison. Inking will be taught in stage 4.

Teenage Boy

A good cartoon looks simple, but you know by now that it is, in fact, very complex. It takes a lot of work to make a finished cartoon look good and simple at the same time.

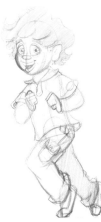

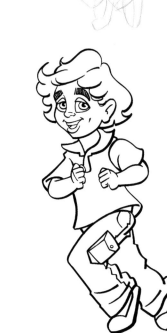

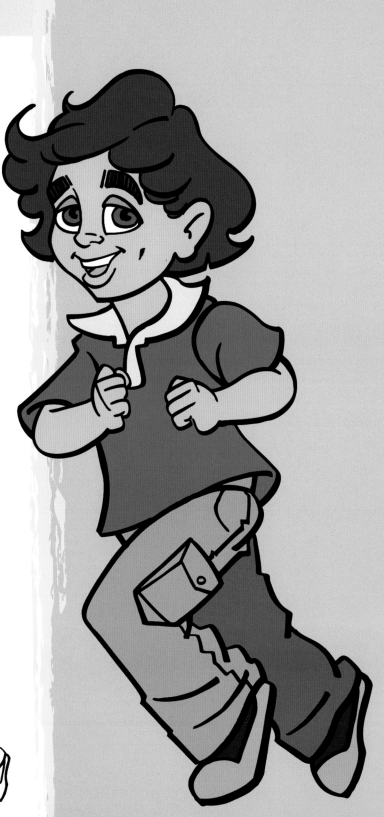

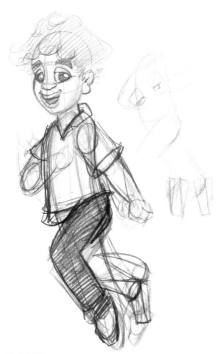

Character Proportions

- This kid is 3½ heads tall. (Compare him to the boy on page 48. See how using taller proportions makes a child look older?)

- The waist ball is ¾ of a head circle tall and is centered with the center of the second head height.

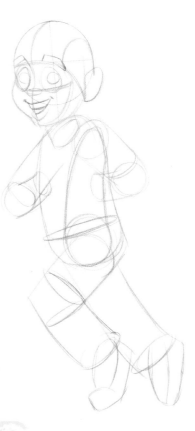

1 First, sketch an idea using any drawing style you want. Add some simple construction to help you understand the pose and character. Redraw any parts you want to improve right next to the original sketch.

2 Draw the pose you want, tracing from prior drawings so you can keep the lines that work and redraw only the ones that need redrawing. Make all needed corrections now. Even try out the final details. Have fun.

3 Trace the construction lines from the previous drawing and finish the construction. This is the key to cartooning 3-D characters. It gives you the proportions of the cartoon and helps you pose them without breaking limbs.

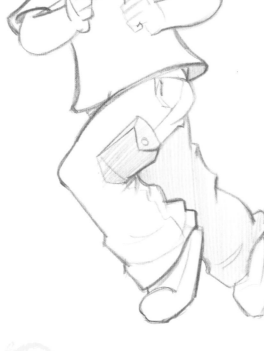

4 Now redraw the final details. Add some basic shading to show depth.

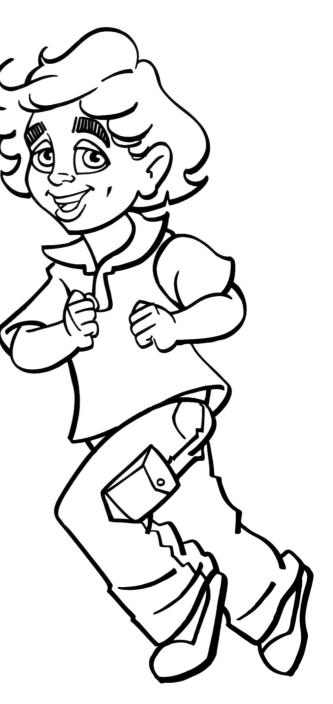

THE INKED DRAWING

Here's the inked drawing for comparison. As you can see, the eyebrows have some inked lines in them, but all the other shaded areas from step 4 are left open to be handled in the coloring stage (stage 5).

Casual Guy

Real-life adult men are around 7 heads tall. In cartoons, head size is always exaggerated at least a bit, so 5 or 6 heads tall is adult height in Cartoonville.

1 Draw an idea, combining your idea sketch with some construction lines. This isn't the construction sketch, but you can still aim to make this adult character around 5 or 6 heads tall.

2 From the sketch in step 1, trace the construction lines, make any needed adjustments and finalize the construction.

Get Into the Head Height Habit

Learn to think in head heights from the moment you start sketching an idea. This will help you establish the character's age easily.

Character Proportions

- This man is 5½ heads tall. Because both of his knees are bent in this pose, the apparent height of the pose is a bit under 5½.

- The waist ball is ¾ of a head circle tall, and its top edge is aligned with the top of the third head height.

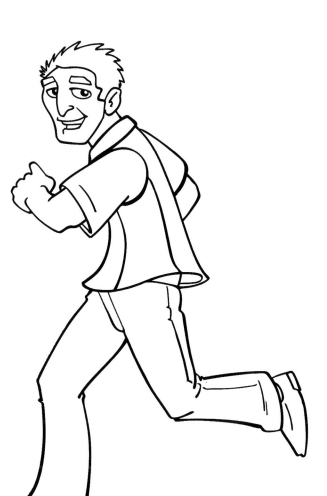

3 Trace the final lines from step 2 onto a new sheet, then add lines for clothing and any other lines you plan to ink.

THE INKED DRAWING
Here's the inked drawing for comparison. Let's move on now to the inking stage!

Make the Silhouette Easy to Understand

A pose should be simple and easy to understand at a glance. If it is not, it may be too complicated.

A good test is to trace the pose and fill it with pencil shading to make a silhouette. Can you easily tell from the silhouette what body parts are where and what the character is doing? If you can, that's good.

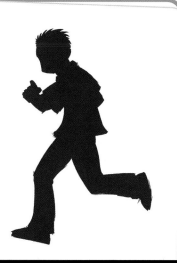

STAGE 4:
Inking

This section gives tips and tricks for inking by hand, the way cartoonists have inked for many years. You'll also learn how to clean up your inking on the computer. Let's get started!

Pen

Soft nib marker

PENS VS. SOFT NIB MARKERS

A felt-tip fine line pen or regular ink pen allows you to add fine detail (note the fine lines in the iris in the top example). However, fine pens also make a slightly shaky line. They are best suited for smaller drawings.

A soft nib marker makes larger and smoother strokes than a pen but cannot draw very fine details. This type of marker is my personal favorite for inking.

You can use both tools in the same drawing if you like.

LINE QUALITY

Variations of thick and thin within an inked stroke are called line quality.

- With a pen, you achieve thicker lines by drawing the outline of the shape you want, then filling it in.
- With a soft nib marker, you thicken a line by pushing down on the marker, forcing the tip to bend and leave a thicker line.

You can add thickness to the end, middle or beginning of a line.

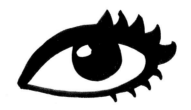

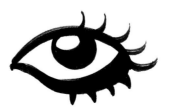

THICKER LINES ATTRACT ATTENTION

Where you put the thicker lines is where the viewer's attention will go first. Look at these examples. Did you tend to look at the thick areas first?

Inking a Drawing

The first step in inking a cartoon is to make a very clean tracing of your drawing using pencil. Lay that on your light table, then place another sheet of paper over it and trace the pencil lines with ink.

The following tips will help you with any kind of hand inking:

- Ink the drawing from the top down.
- Ink with a light hand, meaning do not grip the pen tightly. Avoid tensing up your hand and wrist, as this can lead to aches and pains.
- For the first pass of inking, ink thin lines with no line quality. Then go back and thicken lines where you want to.
- Turn the paper often to avoid inking in awkward positions.

When to Stop Inking

There is no correct answer to this question. I've found that it's hard to know if you have not gone far enough, but easy to recognize when you've gone too far. When you get that gut feeling that you should have stopped earlier, don't worry—simply start over, stopping earlier this time. Think of that sort of trial and error as an enjoyable part of the process.

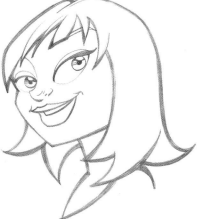

FROM FINAL BLUE LINE TO INKS
Here you can see the sequence of final blue line drawing, pencil "inking" test, the first-pass ink and the final ink.

To me, the final ink feels a little too heavy in the lip area and in the outline of the hair. If I were to try this one again, I would still use lines for shading, but I would space them out more. If that didn't look good, I would start over once more and just leave out the shading lines entirely.

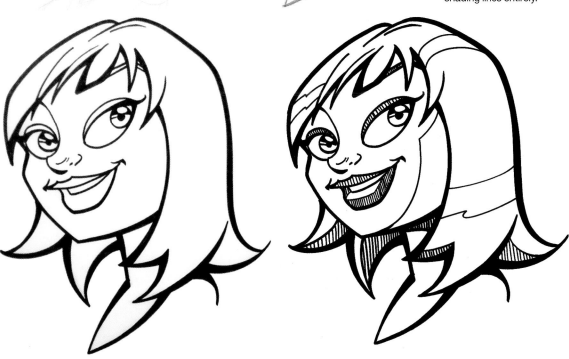

Clean Pencil Tracing

This is the first of two preparatory steps for inking. The purpose of this tracing is to have a neat drawing that shows all the lines you plan to ink and no other lines.

Tip

Sometimes you will need to lift the paper to see your drawing; to do this without shifting the drawing, roll the edge between your first and middle fingers while holding the sheet in place with your thumb.

1 Using your light table, place a clean sheet over your final drawing.

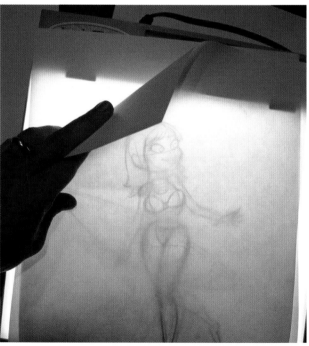

2 If the light is too bright, add an extra sheet of paper below your drawing to darken it up.

 Using any sharp pencil, begin tracing the lines you plan to ink, starting with the head. You can add some line quality, but wait until you trace the whole body to decide how much line quality to add. Everything can be traced using the same pencil.

Here, I have moved the top sheet to the left so you can see the tracing better.

4 Any time the top sheet shifts while you're tracing, carefully realign the drawings and resume tracing.

Tip

Be sure that every color area in the image is completely enclosed, with no gaps in the lines. This looks better and also makes digital coloring easier.

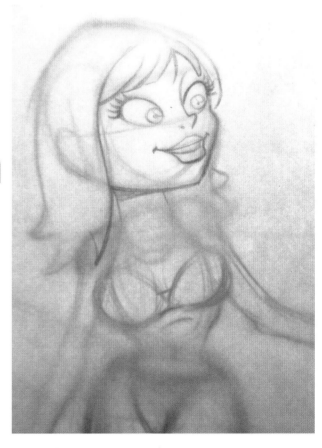

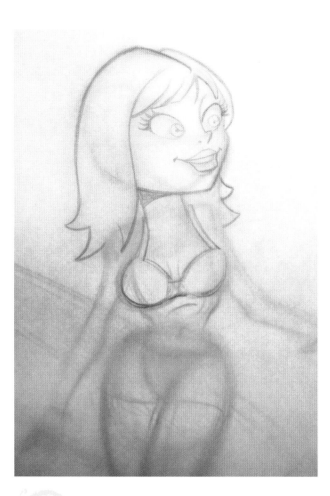

 5 Keep working your way down the body, using the pencil to trace the lines you plan to ink.

For a clean-looking drawing, try to trace each line only once. Going over your lines tends to muddy up the drawing, and the finish will not look finished.

6 If one shape is in front of another, trace the longer lines first to get smooth continuous curves. Here, the legs are in front of a surfboard. I traced the longer lines of the legs first; the lines of the surfboard are broken up anyway.

7 Once you have everything traced, you can go in and add details. Here I merely added some closely spaced lines to the back leg as shading.

Remember, this is not a sketch, but rather the lines you are planning on inking, so you cannot use the pencil to make areas of gray tone. Everything at this stage must be either a line or a solid area of color.

You now have a very clean drawing to trace using ink. Continue to the next page!

Test Your Inking Plan Using Pencil

If you want to see what your final inks will look like before you commit, use a pencil to pretend-ink your drawing. This also lets you test out several versions without using up lots of ink.

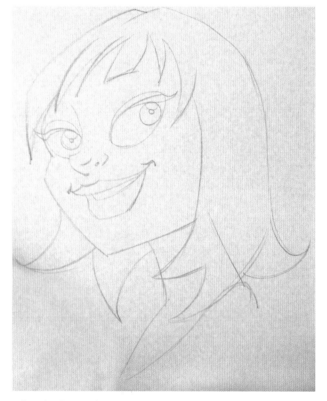

1 Lay the drawing from the previous page (step 7) on your light table with another sheet on top. Using a pencil, trace the entire drawing with simple, thin lines.

2 Now go back and begin adding line quality (page 58) to your drawing. Make lines go from thin to thick. Start at the eyes and darken the pupils first; this helps you see how dark your pencil will go.

Work your way out from the pupils. There is no right or wrong way to add line quality, but you will find that some areas look good thick while others do not.

Concentrate on line thicknesses; don't shade in any large areas yet. Try to make the lines look great.

Tip

Thick, bold lines attract the eye, so place them only in areas you want people to look at.

3 Rotate the paper so you are not tracing in awkward positions. This will help the quality of your strokes tremendously.

4 Use a blank piece of paper under your hand as a smear shield to avoid smearing your pencil lines.

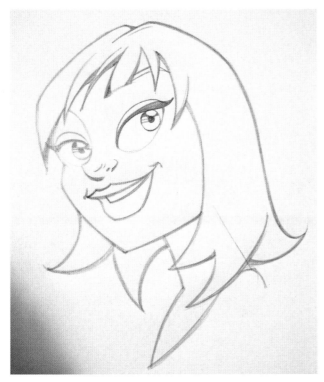

5 Add a level of line quality to the entire drawing before you decide what looks good and what does not. Do not stop and make decisions too early.

6 If the art does not feel right, try thickening just the perimeter lines of the major shapes. Sometimes this trick makes a good sketch look great.

Inking With a Soft Nib Marker

Time to pick up your pen or marker and begin inking! You should use a heavy paper such as marker paper for the best results.

For this demonstration, I will be using a soft nib marker. With this kind of marker, you increase the thickness of the line by pushing down on the marker.

Tip

Rotate your paper as needed to get arcs into a position that feels natural for your hand to trace.

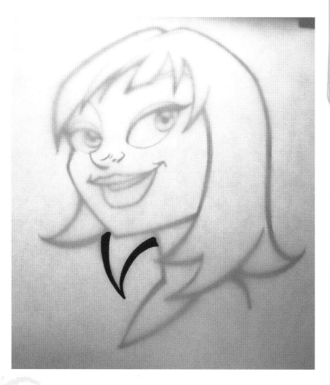

1 Ink on scrap paper for a couple of minutes to get your hand warmed up and in the inking mood.

Lay your final pencil drawing on your light table and put the heavier paper on top. Start inking in an area that is not critical so that you don't feel too much pressure to make a perfect stroke the first time your marker hits the paper. I started with the hair.

2 Spin the paper back around and keep working. Avoid skipping around so you don't forget to ink an area. Be sure to pick up your hand before moving it. Most inks need anywhere from a few seconds to several minutes to dry.

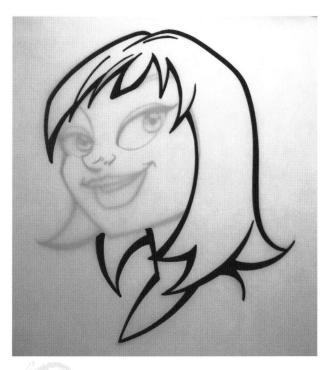

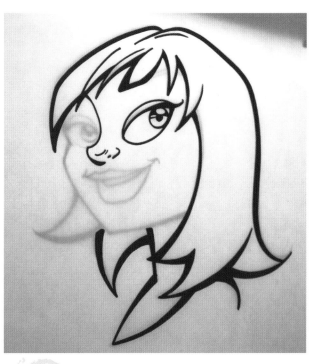

3 Figure out a good inking process for yourself. I try to ink as much as I can in the same section before moving on to something else. Here, I finished as much of the hair as possible.

4 If you are not sure how thick to make a line, keep it thin. You can always come back and thicken it once you have the whole drawing inked, but you cannot make a thick line thinner.

5 If you've followed the entire process step by step, you will have solved the drawing problems long before the inking stage, and you should feel very happy with your finished inking.

Tip

You can use two strokes to create line quality if you need to. Start the second stroke halfway along the first one for a seamless appearance.

Inking With a Pen

Inking with a pen has advantages. You can ink a high level of detail into each drawing. If your drawing is large, though, you will also spend a lot more time inking it with a pen than you would with a soft nib marker. This is why a pen is especially well suited to drawings 8½" × 11" (22cm × 28cm) or smaller. The drawing I am inking in this demonstration is 8½" × 11" (22cm × 28cm).

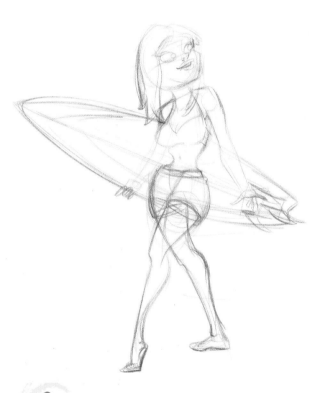

1 Often, professionals draw and ink the art larger than the final size it will be printed at. But there are times when you need to create artwork by hand at the actual size it needs to be. When that is the case, do the whole drawing process at that size so you get used to working in it. Here is the idea sketch.

2 Do another drawing that is more refined. I drew this one right next to the original sketch and at the same size. Drawing each step at the same size helps your hand get comfortable so that "muscle memory" (see sidebar) can kick in.

CARTOONING TERM:
MUSCLE MEMORY

Muscle memory is the tendency of your hand to become accustomed to drawing at a certain size. Your brain and your muscles love repetition. If you draw small, your hand will remember how to draw small. If you change to drawing large, the first few drawings will feel awkward since your muscle memory is set to small.

3 Go through the whole design process until you get to the final drawing, ready to ink.

4 Place the clean drawing on your light table and get a new sheet of paper. Start inking in an area that is not critical; here, I chose the leg. It takes longer for your hand to get used to a small pen than a large marker.

Tip

When inking, use low-tack artist's tape to tape the inking page to the drawing page so they do not shift out of alignment.

5 Work your way down the leg. Add line quality as you go. It will be tough to make large thick areas with a pen, so save that for the end. Detail lines, such as those inside the leg, can be drawn with a thinner line.

Tip

Remember that every color area in the image needs to be completely enclosed, with no gaps in the lines. This makes digital coloring easier.

6 You can fill in some shadow areas with all black (such as the shadows under the cuffs of the swim trunks). For larger areas (such as the shadow behind the leg), you can shade using inked lines instead of filling the area with black.

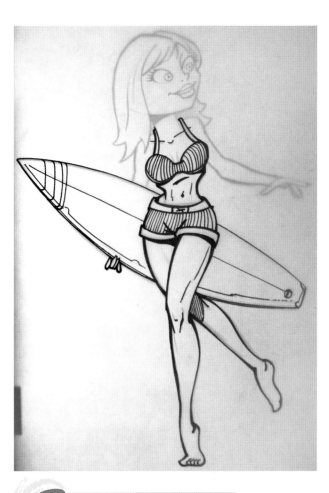

7 Add details as you go. Here, I added pin stripes to the swim trunks. These lines are uniformly thin; however, most of the lines in your drawings should have line quality. You want thicks and thins all over your drawings.

8 Ink what is closer to you first. The surfboard is behind her, so do that after her waist and body.

9 For areas where line quality is detailed and important, such as the hands, do the first pass of inking using the thinnest lines you can. Then go back in and add details and line quality.

Tip

Use the same level of detail in all areas of the drawing. Details attract attention, so make sure you spread them all around the drawing.

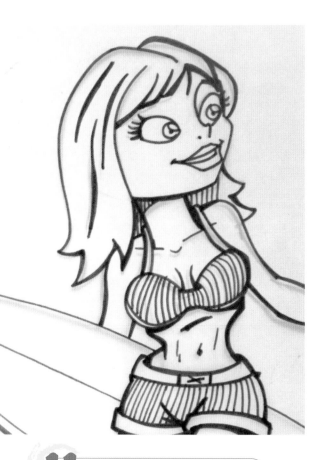

10 After the entire body is inked and the ink is dry, start inking the hair. Use a piece of paper under your inking hand as a shield to protect your work.

11 The facial features are the most important part of a cartoon. By now, your hand should be all warmed up and ready to ink the features. Ink is not forgiving, so take your time and do not rush.

Tip

Practice inking the features of
the face on a separate sheet
of paper. This will help you feel
more confident when you return
to your final ink drawing.

Clean Up Your Inks With Illustrator

Learning to ink takes practice and can be frustrating if you have a shaky hand. Until you develop a good inking style, you can make your inks look better by using Adobe Illustrator to smooth and tighten the lines.

I am using Adobe Illustrator CS4 and Adobe Photoshop CS4 for the demonstrations in this book. Earlier versions will work too.

Tip

If you do not have Adobe Illustrator, that's OK. Complete step 1 of this demonstration to scan your inked drawing, then proceed to the coloring stage (page 80).

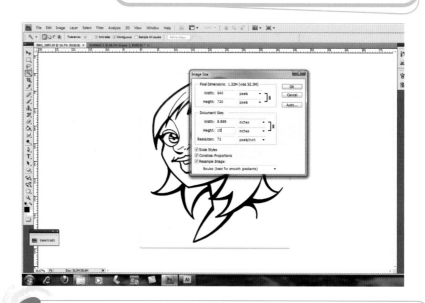

1 Start your scanning software and locate the "professional" or "expert" mode so that you can choose the scan settings.

Preview your scan first so you can select the area to scan. Scan your inks at 1200ppi, using the default settings for photos.

Save the scan on your hard drive. (Keep a copy of this high-resolution scan in a safe place; it's like having a backup of your original inks.)

2 Before you can clean up your scanned inks in Illustrator, you need to scale the image down using Photoshop so that Illustrator will be able to trace it efficiently. Don't worry about loss of image quality; Illustrator will produce a scalable (vector-based) image that you can export to any resolution for printing.

Launch Photoshop. Choose File menu > Open, then navigate to the folder that contains your scanned, inked drawing. Select it and click Open.

Choose Image menu > Image Size. In the Image Size dialog box, do the following steps in order:
- Enable all three checkboxes (Scale Style, Constrain Proportions, and Resample Image).
- If the resolution is higher than 72ppi, reduce it to 72.
- Check the height and width. If the longer dimension is greater than 10 inches at 72ppi, change it to 10 inches.
- Click OK to apply the changes.

Professional Scanning Specs

- Pencil drawings: 600ppi

- Inked drawings: 1200ppi

If your scanner can't go that high, scan at 300ppi, the minimum resolution for a good-quality print.

3 Choose File menu >Save As and save the file as a Photoshop document (*.PSD) in the same folder. Be sure to give it a new name so you do not overwrite your original high-resolution scan.

4 Launch Illustrator. Choose File menu > Open and navigate to the 72ppi Photoshop file you saved in step 3. Select the file and click OK to open it in Illustrator.

From the Tools palette, choose the Selection tool (the solid black arrow).

5 Using the Selection tool (the black arrow), click anywhere on your drawing. A selection box will appear around the art. (It may be a different color than the one shown here.)

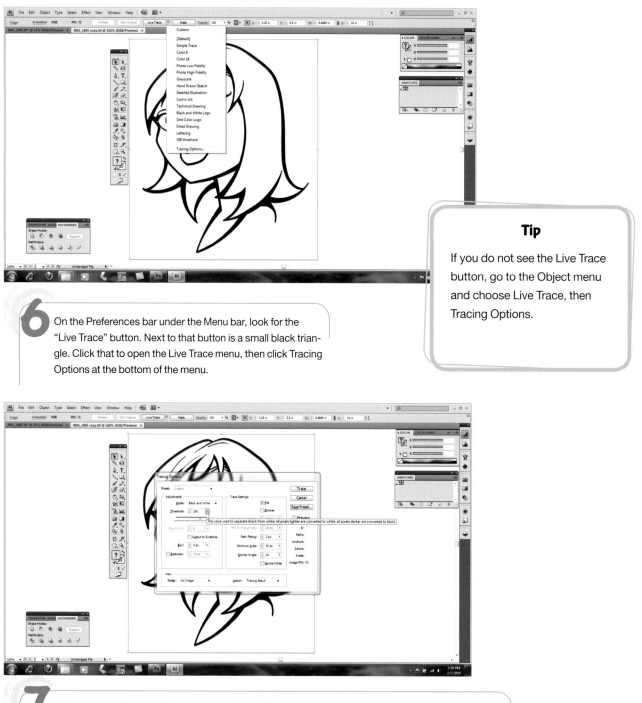

6 On the Preferences bar under the Menu bar, look for the "Live Trace" button. Next to that button is a small black triangle. Click that to open the Live Trace menu, then click Tracing Options at the bottom of the menu.

7 In the Tracing Options dialog box, specify the following settings:
- Mode: Black and white
- Threshold: 200

Now click Trace. Wait for the computer to trace your drawing. This pop up window will close and your screen will refresh with the results.

The goal is for every color area in your art to be completely enclosed by black linework with no gaps in the lines. This looks better and also makes digital coloring easier. If you are not happy with the tracing results, choose Edit menu > Undo and repeat this step using a different Threshold value. Every drawing is different; keep experimenting with the Threshold setting until you like the result.

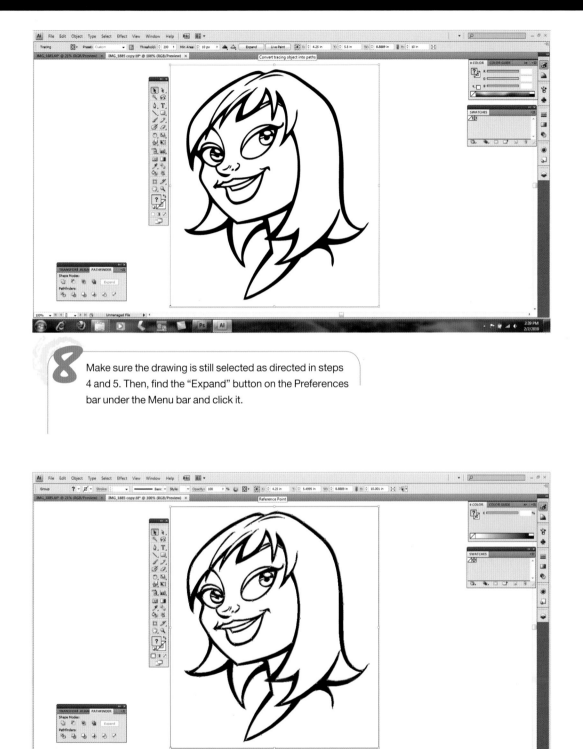

8 Make sure the drawing is still selected as directed in steps 4 and 5. Then, find the "Expand" button on the Preferences bar under the Menu bar and click it.

9 Your drawing has now been expanded into paths. You should see an outline around your inked lines with dots every so often.

10 From the Tools palette, choose the Direct Select tool (the white arrow). Use it to click just to the right of your drawing (be sure to click past the white background box, on the gray area). Your drawing will be deselected. (Another way to do this is to choose Select menu > Deselect.)

Still using the Direct Select tool, click the white background behind your drawing. A box outline and an outline around the silhouette of your drawing will appear. Push the Delete key. This removes the background from your drawing.

11 Choose File menu > Save As. Give your file a new name and save it in the same folder as your Photoshop file. Proceed through the dialog boxes, using all the default options, until your file is saved.

12 Launch Photoshop again. From the File menu, choose Open, then navigate to and open your Illustrator file. An import screen will appear. Select your drawing and set the resolution to 300. Click OK to open the file.

13 Choose File menu > Save As and save your file using a new name. This file is now ready to be colored. (You can add color on the computer, or you can print the image and color it by hand. Both methods will be taught in stage 5.)

Hand-inked drawing

Same drawing scanned, then traced in Illustrator

Final image, digitally colored

14 If you compare your original hand-inked drawing to the one you just traced in Illustrator, you will notice that the traced one looks smoother. Some details are eliminated; some areas are messy. If you don't like the look, you don't have to trace your scanned inks in Illustrator. You can color them in Photoshop (or any other image editing software with layering capability), or you can print the scanned inks and color them by hand.

STAGE 5:
Coloring

Color adds life to your artwork. This section will show you how to color a finished, inked drawing using colored pencils or the computer. Once you learn the principles, you can use them with any other coloring medium you want, such as watercolors, gouache or pastels.

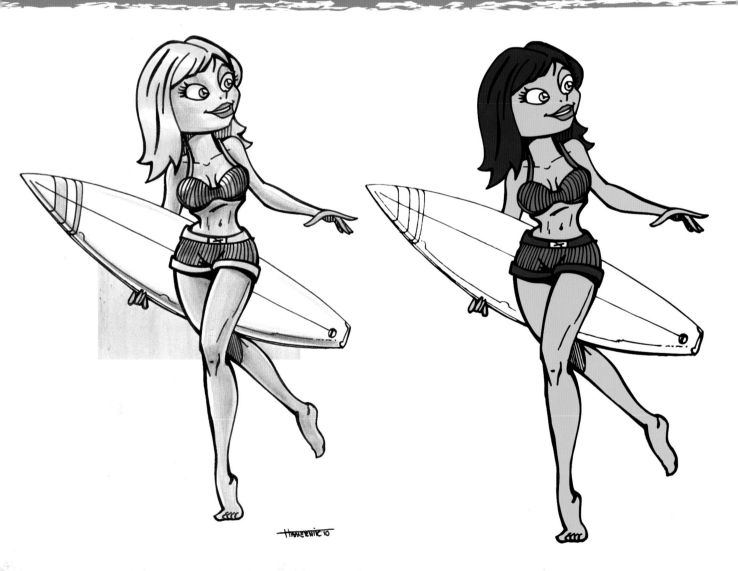

Coloring With Colored Pencils

Here is the approach I use for coloring an inked drawing with colored pencils. I use Prismacolor brand because I like their large selection of colors, but a huge variety of colors isn't necessary, and any brand or type of colored pencil will work fine.

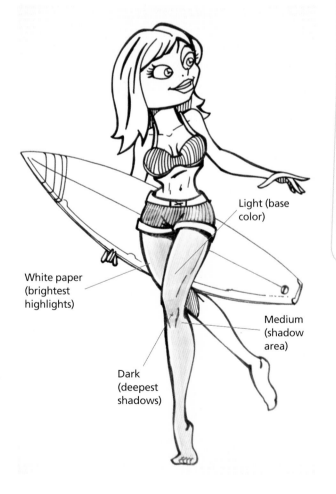

White paper (brightest highlights)

Light (base color)

Medium (shadow area)

Dark (deepest shadows)

Coloring Technique: Modeling

Modeling means using light, medium and dark tones to suggest 3-D form. Tips for modeling with colored pencils:

- Identify the general color you want to use for the object. (Example: light orange.)

- Choose three pencils in that color family: a LIGHT, a MEDIUM, and a DARK. (Example: light orange, medium orange, dark orange.)

- Decide where the light is coming from in your image. The side of the object facing the light source is the highlight side. The opposite side is the shadow side.

- Leave the smallest, brightest highlight areas uncolored. (Think of the white of the paper as the lightest "color" available to you.)

- Use the LIGHT pencil to tone the entire area (other than brightest highlights).

- Use the MEDIUM pencil to add subtle tone to the shadow areas.

- Use the DARK pencil for the darkest shadow areas.

1 Scan your inked drawing (see page 74) before you start coloring. That way, if you mess up or just want to color multiple versions, you can print the scan and start coloring again as many times as you like.

Start coloring in an area of the artwork that is not critical. Use lights, mediums and darks to create the appearance of 3-D form. This is called modeling.

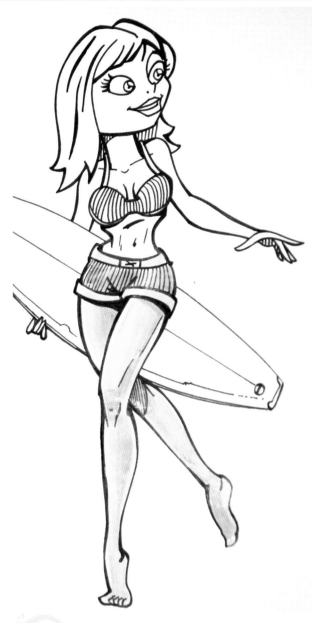

 2 Darken the color in the areas that need it by applying another layer of colored pencil.

Tip

When coloring cartoons, it's usually best to avoid using dark grays or black for shading. Instead, use darker versions of the colors you are using. Cartoons look best when they are brightly colored.

3 Work upward, using the same modeling technique (page 81). Remember to leave the brightest highlight areas paper-white (uncolored). You can use a white colored pencil instead, but I find that the white of the paper is usually brighter.

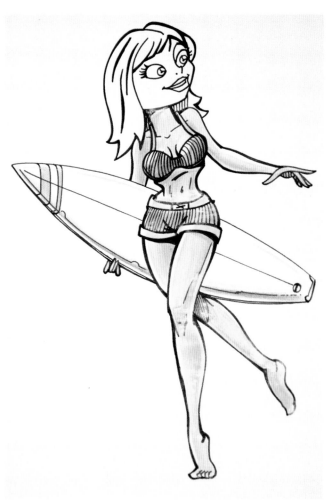

4 Continue working up until every part of the figure except the head has been colored.

5 As you've seen, the white of the paper is your lightest available color and should be used for the brightest highlights. Since the highlights are the lightest part of the image, everything else needs at least a little bit of tone—even white-colored objects, such as this surfboard. Use a very light gray or light blue to represent white.

Tip

If you are getting a lot of lines in your colored-pencil work, try moving the pencil in tiny circles instead of side to side.

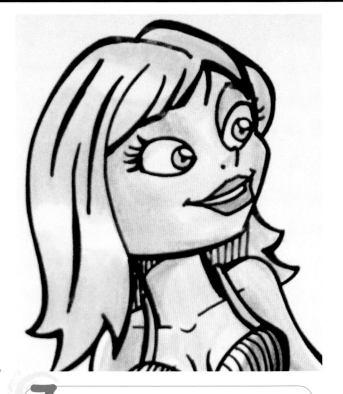

6 Color the head last. Fill in the face with the lightest version of the face color, then go back in with the medium and dark versions to add the shadows that create the shape of the face.

Color the hair the same way, starting with your lightest version of the hair color and then adding subtle shading with the medium and dark versions. You can make hair look shiny by leaving a soft-edged band of uncolored paper for a highlight.

Lips can be filled in with one flat color.

7 Color the eyes. Leave the highlights on the irises paper-white. The "whites" of the eye are not as bright as highlights, so give them a little tone using a very light gray or blue.

Add a curved band of slightly darker tone along the top edge of each eye to suggest the shadow cast by the brow. This curved shadow helps the eyes look round.

8 Use a piece of paper as a shield to protect part of the background. Color right over the edge of the shield. When you remove the shield, you'll have an area of color with a nice, crisp edge. Repeat for two crisp edges.

9 Evaluate the finished job and touch up or darken any areas that may need extra attention. You can always darken colored pencils, but you cannot lighten them.

Here is a scan of the final art.

Coloring a Simple Image With Illustrator

I'm going to show you a technique for using Adobe Illustrator to quickly add "flat colors" to your artwork, meaning one color per ink-surrounded area.

In later demos, we will be using Photoshop to add shadows and highlights over the flat colors. It is possible to use Illustrator to add shadows and highlights, but those techniques are not covered in this book. I highly recommend taking a class in Illustrator at your local community college or online to learn more about all the things it can do.

1 This demonstration assumes you have scanned an inked drawing and prepared it in Illustrator using the instructions on pages 74–79.

Launch Illustrator. Choose File menu > Open. Navigate to where you saved your inked drawing, select it, and click Open.

2 Choose Select menu > Select All. The entire image should now be selected. (If the lines do not look traced as shown here, you need to complete the steps on pages 74-79 first, then return to this demonstration.)

Watch Video Tutorials

To see video demonstrations of these and other Illustrator techniques, visit my blog:

http://tutorialsbyharry.blogspot.com.

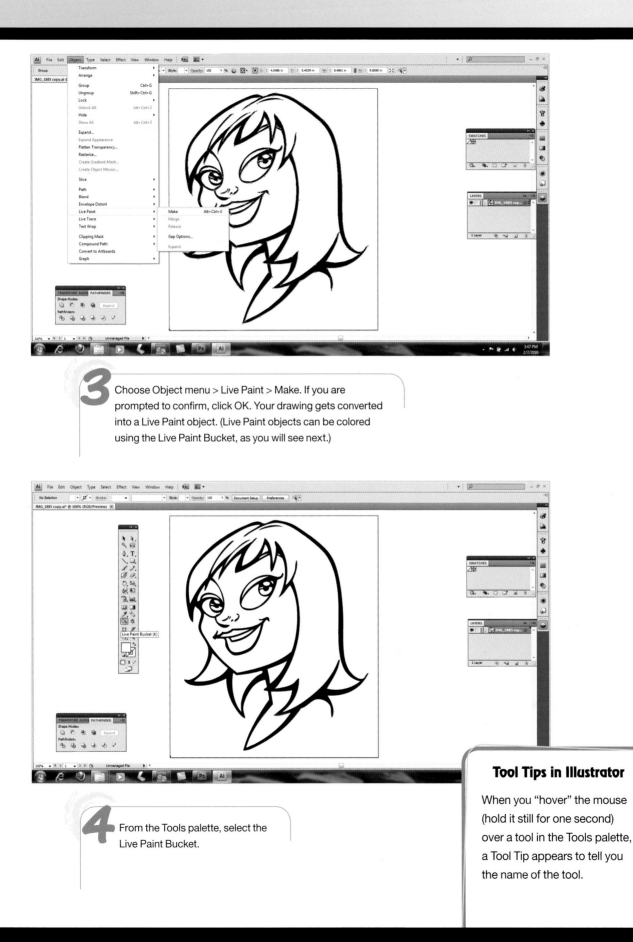

3 Choose Object menu > Live Paint > Make. If you are prompted to confirm, click OK. Your drawing gets converted into a Live Paint object. (Live Paint objects can be colored using the Live Paint Bucket, as you will see next.)

4 From the Tools palette, select the Live Paint Bucket.

Tool Tips in Illustrator

When you "hover" the mouse (hold it still for one second) over a tool in the Tools palette, a Tool Tip appears to tell you the name of the tool.

5 From the Window menu, choose Swatches to open the Swatches palette. This palette has small buttons at the bottom. Find and click the Swatch Libraries button; it looks like two overlapping file folders.

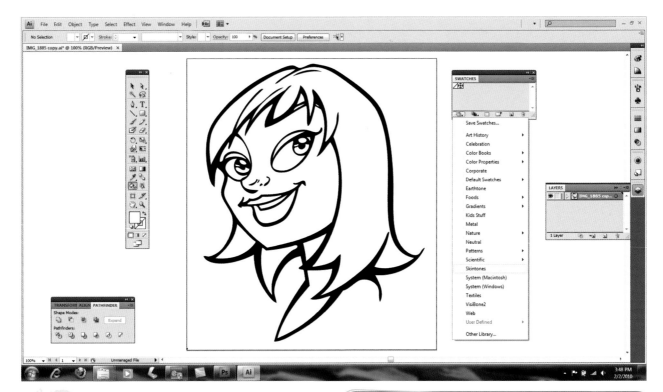

6 When you click the Swatch Libraries button (step 5), you will see a drop-down menu containing numerous swatch palettes you can open and use.

For this demonstration, choose the Skintones palette and two or three other palettes that interest you.

Use Illustrator's Specialized Color Palettes

The default RGB palette in Illustrator provides a basic set of colors. You have to figure out which ones look good together.

More useful are the specialized palettes (such as Skintones, Kids Stuff, and others) which contain multiple shades of selected colors that look good together. When coloring a cartoon, choose all your colors from one of these palettes, and you will get a pleasing result with much less effort.

Step 5 (above) shows you how to find and open these palettes.

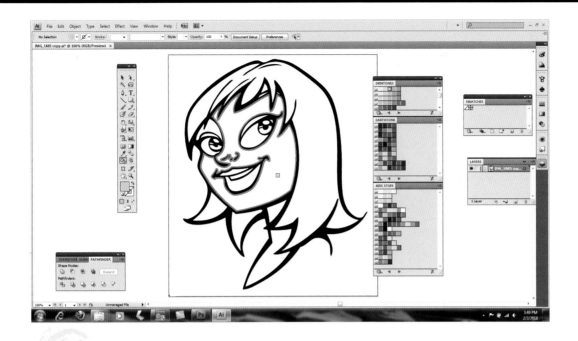

7

We're going to color the face first. Select a skin tone by clicking it in the Skintones palette.

Select the Live Paint Bucket tool if it is not still selected. Move the mouse over your art, and you will see red outlines appear and disappear; each one indicates an area you can color using the Live Paint Bucket. The red outlines do not print.

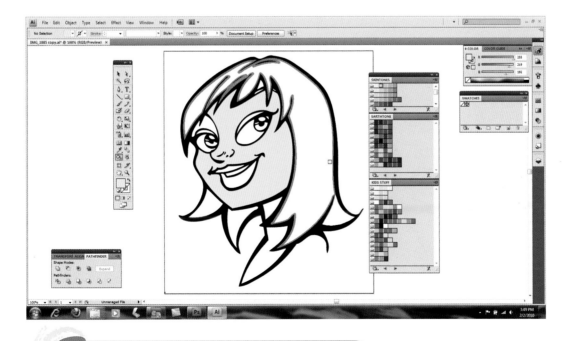

8

Move the Live Paint Bucket over the face area, then click once. The face will be filled with the color you selected from the Skintones palette in step 7.

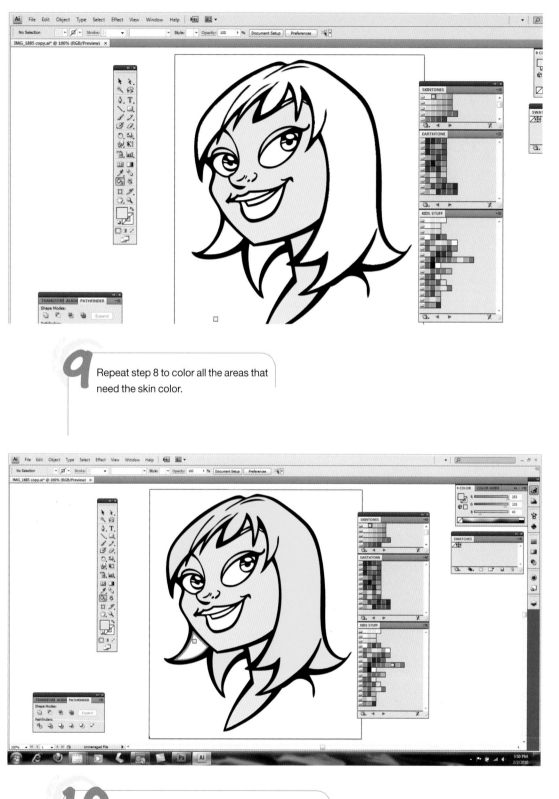

9 Repeat step 8 to color all the areas that need the skin color.

10 Choose a color for the hair from your swatches palette, then use the Live Paint Bucket to color all the hair areas.

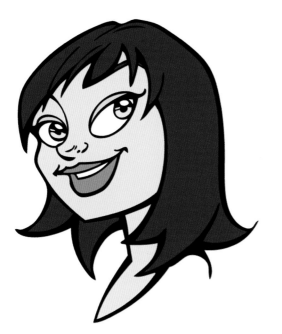

11 Continue until all areas are colored. Live Paint colors can be edited, so if you change your mind about a color, simply choose a new color from a palette and use the Live Paint Bucket to fill areas with the new color.

12 When you are done coloring, choose File menu > Save and save the file using the default format (*.AI).

Coloring a Detailed Image With Illustrator

Adding flat colors in Illustrator can save you a lot of time
if you have many pieces to color. The artwork for this
demo is larger and more detailed than that in the previ-
ous demo, so this time I will show you how to zoom and
scroll. I will also show you how to fix gaps in the inking
and how to avoid (and undo) common mistakes.

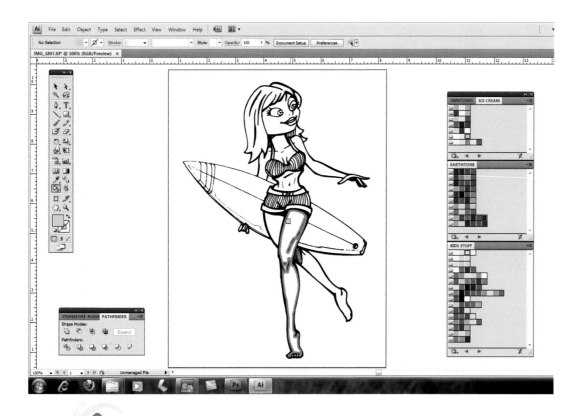

1 Prepare an inked drawing for digital coloring as follows:
- Scan the inked drawing and trace it in Illustrator as directed
 on pages 74–79.
- Open the file in Illustrator (File menu > Open), select the entire
 image (Select menu > Select All), and convert it to a Live Paint
 object (Object menu > Live Paint > Make). (For screen shots
 to guide you, see pages 86–87, steps 1–3.)
- Begin dropping color into areas using the Live Paint Bucket,
 as in the previous demonstration.

2 When you need to zoom in to color smaller areas, use the Zoom tool (the one that looks like a magnifying glass).

Keyboard Shortcuts for Illustrator

- Click on the drawing to zoom in toward the spot you clicked.

- Option-click (Mac) or Alt-click (PC) on the drawing to zoom out.

- Click and drag to select and zoom in on a specific area.

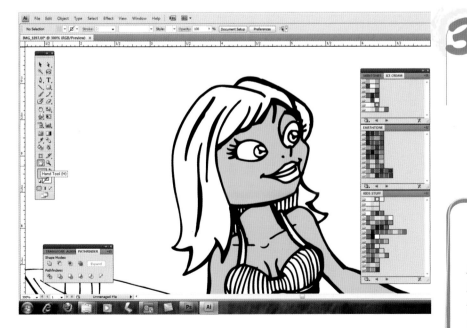

3 When you are zoomed in, you may need to scroll around in the drawing to see different areas. The Hand tool (it looks like a hand) is easier to use than the scroll bars. Click and drag with the Hand tool to move around the drawing.

Keyboard Shortcut for Illustrator

Anytime you are using the Zoom tool, you can switch temporarily to the Hand tool by holding down the space bar on your keyboard.

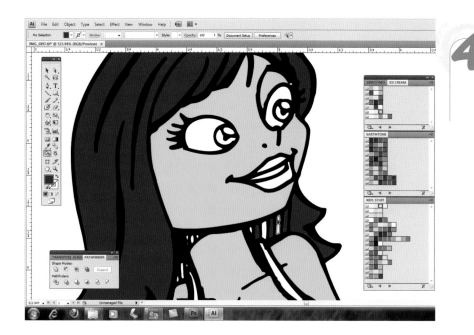

4 Zooming in and moving around as needed, continue filling areas using the Live Paint Bucket.

To save time, finish all areas of one color before selecting the next color.

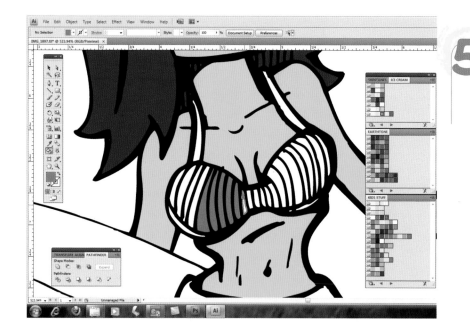

5 Continue filling areas with the Live Paint Bucket. If the art has small details, you will have to spend a lot of time zooming in on and filling the small areas. This takes time and patience.

Tip

Remember to take advantage of the specialized color swatch palettes! (See page 88.)

Unwanted white space in the inking

6 Some areas of the inking may have small areas of white that should not be there. To save time, you can use the Live Paint Bucket to color those areas with black. This will blend them into the inked lines.

Avoid Coloring the Lines

As you're moving the Live Paint Bucket around the art, sometimes the entire drawing will become outlined with red. This means the black lines are selected. If you click now, the lines themselves will be colored (which you don't want).

If all the black lines seem to disappear suddenly, that's a clue that you have accidentally colored the lines.

Choose Edit menu > Undo to fix the mistake. Choosing Undo one time will undo your most recent change. Choosing Undo again will undo the change before that. By default in Illustrator, you can undo up to your last twenty changes.

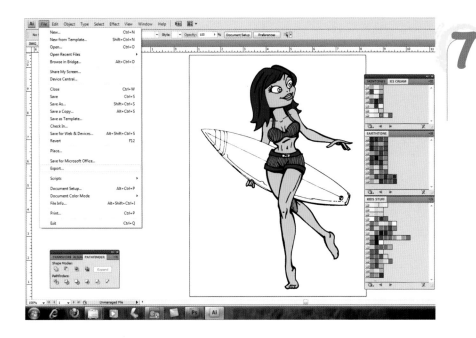

7
When you are done coloring, save your file under a new name in Illustrator (*.AI) format.

After saving the Illustrator file, you can export it to a Photoshop file (*.PSD). Later, you can use Photoshop to add highlights and shadows. (Those techniques are taught in the demonstration that starts on page 106.)

To begin exporting, choose File menu > Export.

8
When the Export window appears, choose a folder, name the new file and select the file type you want to export to. I am exporting to a Photoshop file. Click Save.

9
An Export Options window will appear. Choose the following settings:

• Resolution: High (300ppi). This is the minimum resolution for a good-quality print.

• Enable the Write Layers option and check Maximum Editability.

• Enable the Anti-alias option so that the edges of your image will blend into the background and appear less pixelated.

Click OK to export. The exported file is ready for continued coloring or manipulating in Photoshop.

Tip

Open the Illustrator file you saved on page 91, then export it to a Photoshop document using the steps on this page. When we get to the demonstration about adding highlights and shadows in Photoshop (page 106), you will have one more image to practice on.

Coloring With Photoshop

In this demo, I will show you how to color artwork using Photoshop instead of Illustrator. If you do not have Photoshop, you can do the same basic steps in any paint program.

Get Video Tutorials

For video demonstrations of these techniques, visit:

http://tutorialsbyharry.blogspot.com.

 1 Launch Photoshop. Choose File menu > Open and open the inked drawing you want to color. If you are opening an Illustrator file, a pop-up window will appear. Select your drawing, set the resolution to 300 and click OK.

2 Choose Window menu > Layers to open the Layers palette. Double-click the layer name "Layer 1" and change it to "Line Art."

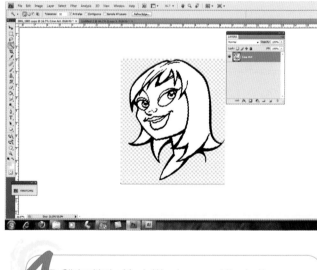

3 From the Tools palette, select the Magic Wand tool. (It may be hidden under the Quick Selection Wand; click and hold the mouse on the Quick Selection Wand, then choose the Magic Wand tool from the pop-up menu.)

When the Magic Wand is selected, look for the Options Bar (it's under the Menu Bar) and uncheck the Contiguous option.

4 Click with the Magic Wand on any white pixel in your drawing. All the white areas in the drawing should now be selected. (Selected areas in Photoshop have a moving dotted line around them called "marching ants.")

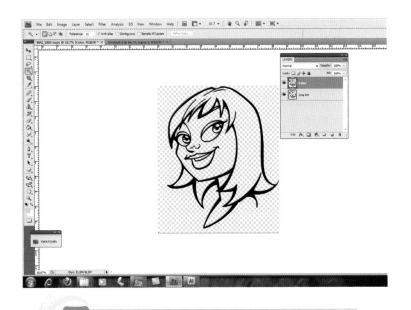

5 Push the Delete key on your keyboard. All the white areas of your artwork will be deleted.

From the Select menu, choose Deselect to drop the current selection. You should no longer see the "marching ants".

6 The Layers Palette (Window menu > Layers) has buttons along the bottom. The second button from the right is the New Layer button. Drag the Line Art layer down to the New Layer button and drop it there, as shown.

7 Your Layers palette now contains a second layer called "Layer 1 Copy." Rename this layer "Color." (To rename a layer, double-click its name.)

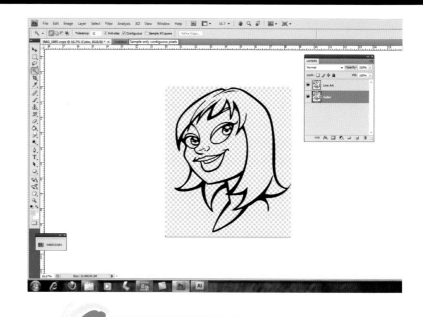

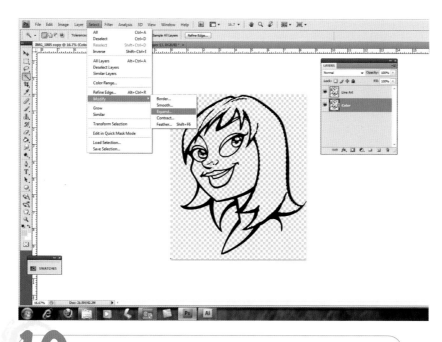

8 Now, in the Layers palette, drag the Color Layer down below the Line Art layer. (You want the black lines on top so that they will hide the edges of the color areas.)

9 If the Color layer in the Layers palette is not still blue (indicating it is selected), click it once to select it.

Choose the Magic Wand tool; then, in the Options bar, check the Contiguous option.

10 Click the Magic Wand tool on the first area you want to color (I have selected the hair).

Choose Select menu > Modify > Expand. In the pop-up window, specify 2 pixels, then click OK. You will see that the selected area grows slightly in size. (If you didn't expand the selection in this way, you could end up with a thin white gap between the coloring and the linework.)

Tip

If all areas of the artwork become selected after one click of the Magic Wand (step 10), go back to step 9 and make sure the Contiguous option is checked.

After that, if you are still finding that more than one color area is selected by the Magic Wand, there may be a gap in your black linework. Use the Brush tool to fill in any gaps with black, then try step 10 again.

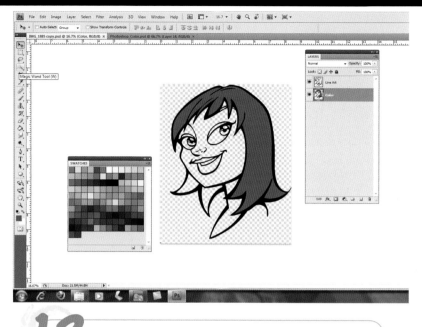

11 Choose the Paint Bucket tool from the Tools palette. (The Paint Bucket is hidden under the Gradient tool; click and hold on the Gradient tool, then click the Paint Bucket tool when it appears.)

12 The area you plan to color should still be selected; if not, make a selection and expand it as directed in step 10 and then switch back to the Paint Bucket tool.

Choose a color from the Swatches palette by clicking it, then click the Paint Bucket tool on the selected area of your image to "pour" color into it.

Choose the Magic Wand tool again.

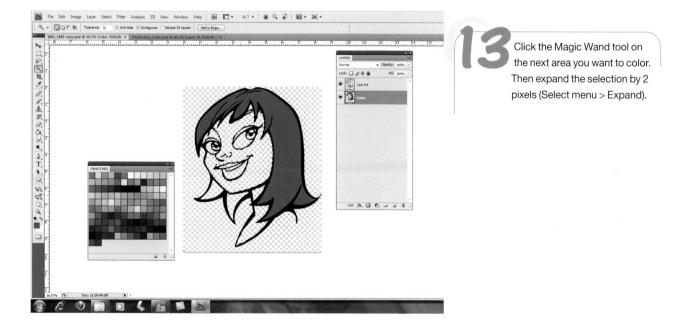

13 Click the Magic Wand tool on the next area you want to color. Then expand the selection by 2 pixels (Select menu > Expand).

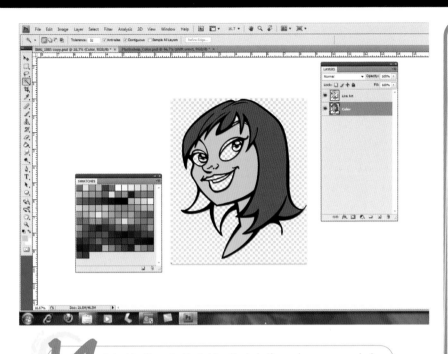

Shortcuts for Photoshop: Color Swatches and Filling

The current foreground and background colors are shown in the two squares at the bottom of the Tools palette.

- Click a swatch in the Swatches palette to set the foreground color.

- Command-click (Mac) or Ctrl-click (PC) on a swatch to set the background color.

- Option-backspace (Mac) or Alt-backspace (PC) to fill the current selection with the foreground color.

- Command-backspace (Mac) or Ctrl-backspace (PC) to fill the current selection with the background color.

14 I decided I wanted to lighten the hair. If you change your mind about a color, simply select the areas of the old color using the Magic Wand, then choose a new swatch and use the Paint Bucket tool or Option-backspace (PC: Alt-backspace) to fill the selection with the new color.

Shortcuts for Photoshop: Zoom Tool

- Click with the Zoom tool to zoom in.

- Option-click (Mac) or Alt-click (PC) with the Zoom tool to zoom out.

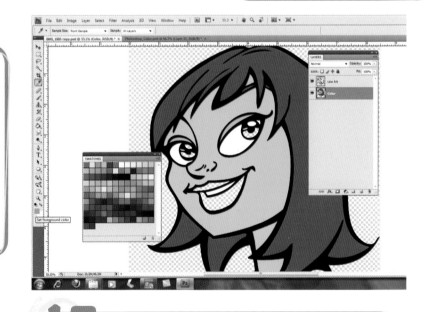

15 You can zoom in on small areas using the Zoom tool, the one that looks like a magnifying glass. While zoomed in, you can scroll around the image by clicking and dragging with the Hand tool, just as in Illustrator.

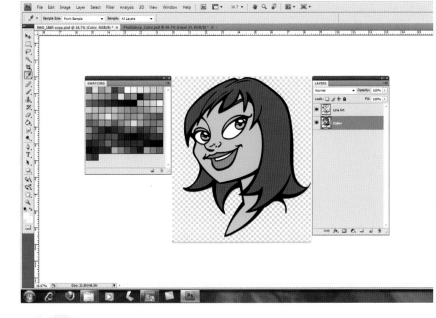

Tip

Choose Window menu > Swatches to open the Swatches palette. Click the small black triangle button to open the Palette Options. Select "Large thumbnail" for a better view of the swatches.

16 Repeat the process of selecting an area with the Magic Wand, expanding the selection and filling the selection with color until all areas of the cartoon are colored. (Leave the background empty.)

How to Create a Custom Color Swatch in Photoshop

1. Open the Color Picker (shown here) by clicking the foreground color box at the bottom of the Tools palette (shown in step 15).

2. Move the slider next to the rainbow color bar to the desired hue. Then click around in the large box until you have the specific tint or shade you want.

3. Click OK to close the Color Picker. The custom color is now the foreground color, and you can paint with it.

4. To save your custom foreground color for later use, click anywhere in the gray area of the Swatches palette, then name your swatch and click OK. (Another way to retrieve a custom color is to sample it from the artwork by clicking it with the Eyedropper tool.)

17 Now we'll prepare to add a background color. Go to the Layers palette (Window menu > Layers) and click the New Layer button (the one next to the trash can).

18 Choose a color swatch for the background, then—without making a selection—click anywhere in the image with the Paint Bucket tool. The entire image will appear to be filled with color. Don't worry; only the new layer has been filled.

Now let's move the background color to the back where it belongs. Go to the Layers palette (Window menu > Layers) and drag the new layer down until it is under the Line Art layer, as shown here. Now you can see the lines, but your colors are still hidden behind the new layer. This is a good demonstration of how layers work in Photoshop if you've never used them before.

19 Drag the new layer down again until it is under the Color layer. Now the background color is behind everything else.

Save your finished image with the separate layers in *.PSD (Photoshop) format so that you can go back later and change the background color or even the colors in the character if you want to.

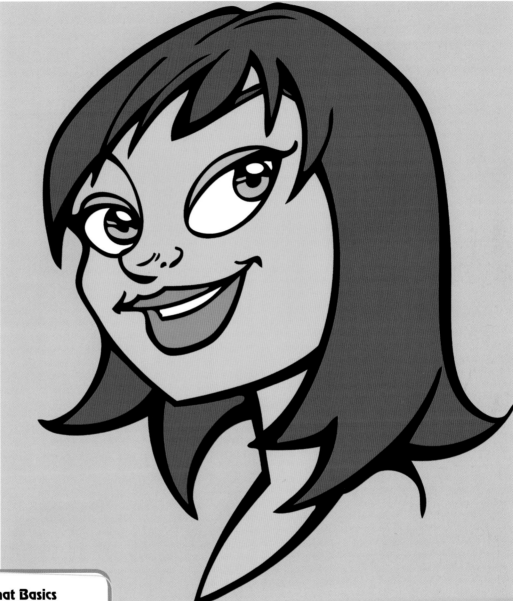

File Format Basics

To save your Photoshop image in another format for printing or sharing, choose File menu > Save As. A TIFF file without layers is good for printing and will take up less disk space than the .PSD file. A JPEG will be even smaller and is good for e-mail or posting to the Web.

Add Shadows and Highlights With Photoshop

In the previous digital coloring demonstrations, we've colored each ink-surrounded area with only one color. (This is called "adding flat colors" or "flatting.")

Flat colors can look good all by themselves, but many artists will go a step further and add some shadows and highlights to those areas of flat color. This demo will show you how to do that using Photoshop.

1 Open the layered Photoshop file you saved at the end of the previous demonstration (page 104).

The Layers palette (Window menu > Layers) shows thumbnail-size images of the contents of each layer. Look for the layer named Color. Now Command-click (Mac) or Control-click (PC) the thumbnail image of the Color layer. The outline of your character should now be selected (indicated by the "marching ants").

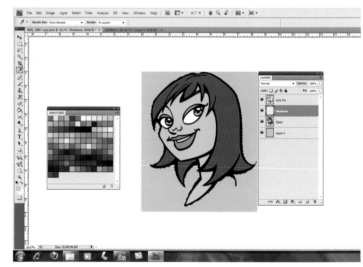

2 Click the new layer icon button at the bottom of the Layers palette.

3 A new layer appears in the Layers palette. Double-click the layer name and change it to Shadows.

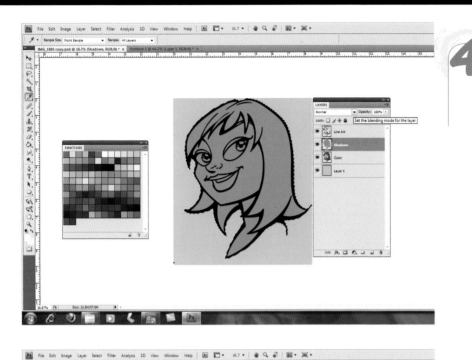

4 Choose a medium gray swatch from the Swatches palette. Make sure in the Layers palette that the Shadows layer is blue (indicating it's the active layer), and make sure you still have the layer contents selected per step 3. Then use the keyboard shortcut Option-backspace (Mac) or Alt-backspace (PC) to fill the selected area with the medium gray. All of your coloring will now appear to be covered by gray.

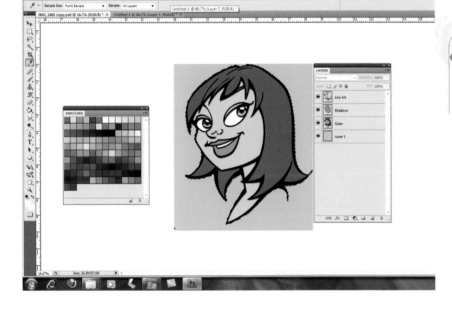

5 Note that the blending mode for the Shadows layer is set to the default mode, Normal. Click the black triangle and choose Overlay from the pop-up menu. You should now see your colors again, although the thumbnail for the Shadows layer in the Layers palette will still show the gray.

Important: In the Layers palette, Command-click (Mac) or Ctrl-click (PC) the Shadows layer bar to exit blend selection mode and deactivate that layer.

Photoshop Shortcut:
Selecting the Contents of a Layer

Command-click (Mac) or Ctrl-click (PC) on a thumbnail image in the Layers palette to quickly select the entire contents of that layer.

Tip

To learn what the various layer modes do in Photoshop, search the Web for *Photoshop blend modes*.

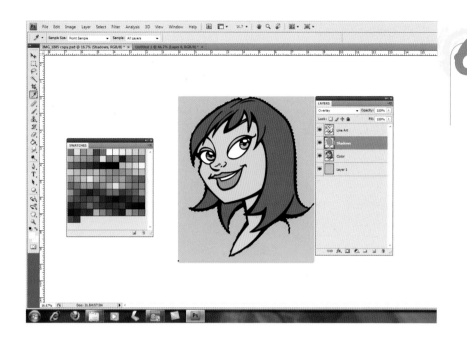

6 In the Layers palette, click the Shadow layer to select it again. (Steps 5 and 6 are important. You have to deselect the layer to exit blend selection mode.)

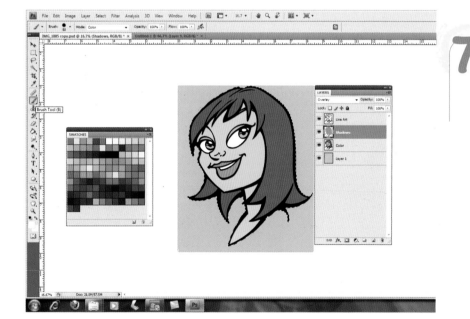

7 From the Tools palette, choose the Brush tool. (It may be behind the Pencil tool; click and hold the Pencil, then click the Brush when it appears. Make sure you have the Brush tool selected and not the History Brush tool.)

Shortcut for Photoshop: Press a Key to Switch Tools

Another way to switch to the Brush tool is to press the letter B on your keyboard. If the Pencil tool is in front, pressing B selects the Pencil tool. If this happens, hold down the Shift key while pressing B to get to the Brush tool.

 8 Click the foreground color swatch at the bottom of the Tools palette to open the Color Picker. Choose a dark gray, one that is close to black.

9 Make sure the Brush tool is still selected (step 7). The Options bar (under the Menu bar) shows the shape of the current Brush Preset. Click the button next to the shape, and the Brush Preset picker will open.

Choose a brush size and set the Hardness to 0. Press Enter on your keyboard to close the Brush Preset picker.

10 In the Layers palette, make sure the Shadows layer is still selected (blue). Click the lock icon for the Shadows layer to turn on the "Lock Transparent pixels" option. This option prevents you from painting any pixels that are not already colored. (Remember that, although you can't see the gray right now, all the pixels in the Shadows layer are either gray or transparent.)

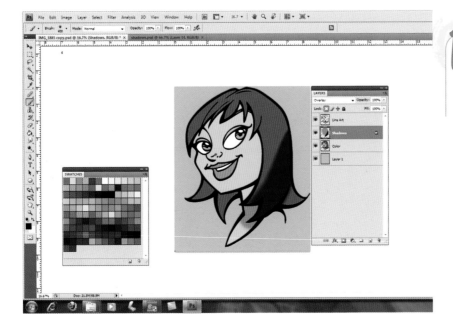

11 Make sure the Shadows layer is still selected (blue). Using the Brush tool with the dark gray color, click and drag to paint shadows.

Thanks to the "Lock Transparent Pixels" option, the empty pixels around the image will not be altered, so you can paint freely past the edges of the colored areas.

At this stage, the shadows will look very dark. That's okay.

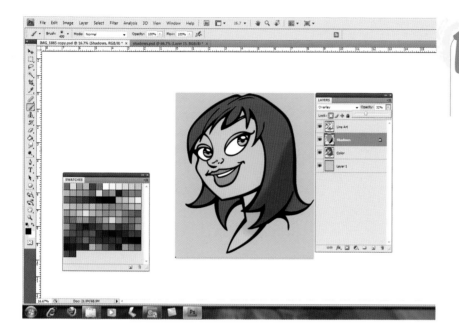

12 Lighten the shadows by lowering the opacity of the Shadows layer in the Layers palette. Try an opacity of 30% or whatever looks good on your screen.

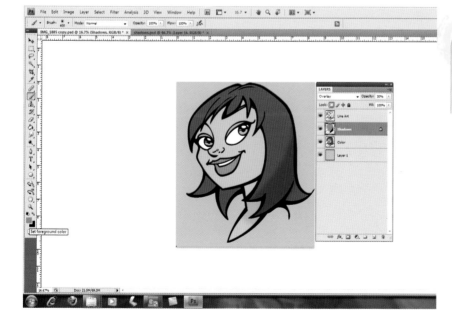

13 You'll recall that the current foreground and background colors are shown in two boxes at the bottom of the Tools palette. Above those boxes is a curved arrow. Click the arrow to swap the foreground and background colors. The dark gray you painted with in the previous step is now the background color.

Next, open the Swatches palette (Window menu > Swatches) and click the same medium gray swatch you used in step 4. Now the foreground color box contains the medium gray, while the background color box contains the dark gray.

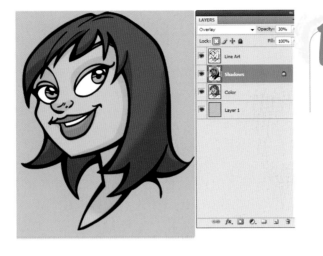

14 Let's review:

- Medium gray and dark gray are the current background and foreground colors (step 13).
- You know that painting with the dark gray creates a shadow (step 11).
- The medium gray covers your entire cartoon (step 4); it just isn't visible because the Shadows layer is in Overlay mode (step 5).

Therefore, you can use the medium gray like an eraser to make corrections to your shadows.

Paint the shadows using the dark gray; erase by painting with the medium gray. It's easy to switch between the two colors; just swap the foreground and background colors by clicking the curved arrow or pressing X on your keyboard.

Add as many shadows as you like. This step takes time.

Shortcuts for Photoshop: Swapping the Foreground and Background Colors

The two boxes at the bottom of the Tools palette show the currently selected foreground and background colors.

- Click the curved arrow to swap the foreground and background colors.

- Pressing X on your keyboard does the same thing.

15 Next, we're going to add highlights using a process much like the one we used to add the shadows.

Repeat steps 1–5 on pages 106–107, except this time, rename the new layer "Highlights."

Lock transparent pixels for the Highlights layer by clicking the lock button in the Layers palette.

To paint highlights, you will use white, so let's replace the dark gray swatch at the bottom of the Tools palette with white. Click the swatch to open the Color Picker, then choose white (R:255, G:255, B:255) and click OK.

The medium gray is still your "erasing" color.

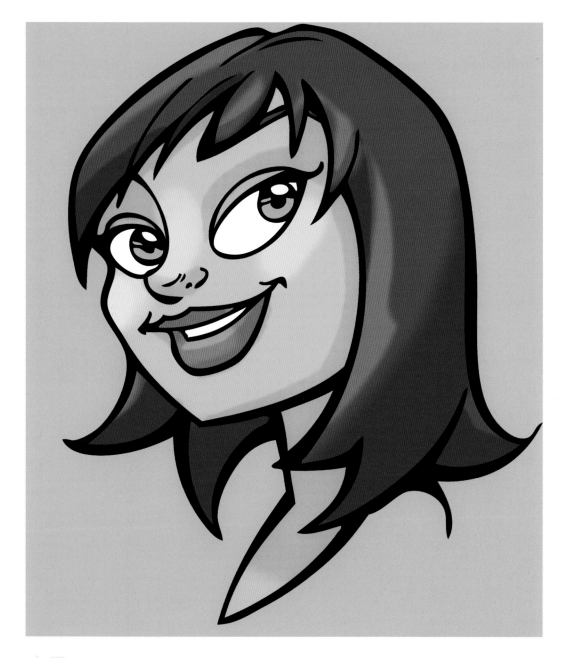

16 Using white, paint highlights on the face, lips and hair. Correct mistakes by painting with medium gray. Remember, it's easy to swap the background and foreground colors by clicking the curved arrow or pressing X on your keyboard.

Take your time and paint in as many highlights as you like.

The Layers palette is shown here next to the finished art. You can see that the dark gray in the Shadows layer produces the shadows, while the white areas in the Highlights layer produces the highlights.

LAYERS

Overlay ▾ Opacity: 53%

Lock: 🔲 ✒ ✛ 🔒 Fill: 100%

👁 Line Art

👁 highlights 🔒

👁 Shadows 🔒

👁 Color

👁 Layer 1

STAGE 6:
Practice!

Keep practicing what you've learned. This section is a collection of examples that use all the steps I covered in this book.

Sometimes, though, you will not feel like following a process for creating characters. At those times, just sketch in your sketchbook.

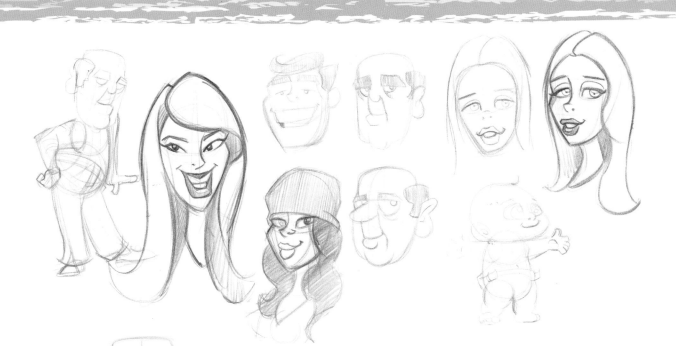

The "Five Seconds" Challenge

Look around and find a person you don't know. Stare at the person's face for only five seconds, trying to memorize it. Now look down at your sketchbook and draw what you remember. Whatever features you don't remember, simplify. The traits you remember will be the most important ones about that face.

Beefy Guy

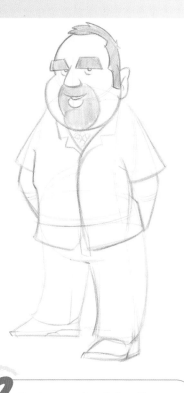

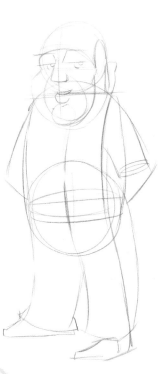

1 Choose one or two heads from your sketchbook and redraw them larger. Add details to them. Be sure to use some basic construction to reinforce the techniques we have been learning.

Do several drawings of these same heads until you have a drawing you like.

2 Re-draw your favorite head from step 1. Measure the head, then mark off a total height for the character. Design a body to fit into that area.

3 Create a final construction sketch in which you focus just on the shapes and head heights for your character. These are the proportions that make the character look the same every time you draw it.

4 Do the turn-around chart. This is an essential step. It does take time— and, yes, it may be boring—but the turn-around chart will save you a lot of time later when you are trying to pose your character.

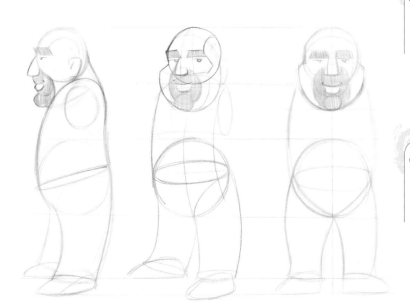

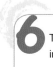

5 Stick-figure time! Do twenty or more poses using stick figures. Try to capture the action while maintaining the proportions of the character.

Reminder About Stick Figures

Include shoulder and waist lines in every stick figure, and use the counterbalancing principle (page 37) to create attitude and expression in your stick figures. If you can get a stick figure to have attitude, your final cartoon will be fantastic.

6 Trace a clean final drawing, then ink, scan and color.

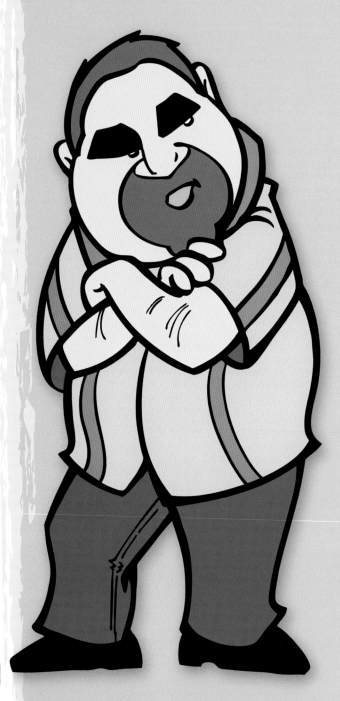

Martial Arts Man

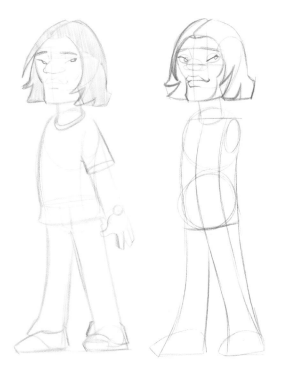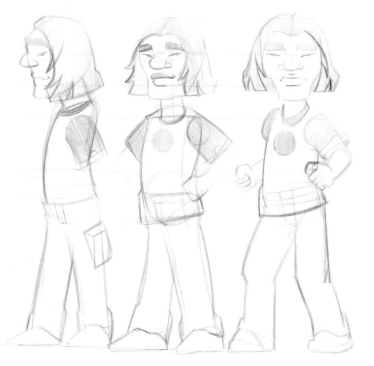

1 Try another head from the page of heads you drew at the beginning. Using the basic 3/4-view standing pose, design your character's basic proportions and appearance (left).

Then do a final construction sketch (right).

2 On a new sheet, trace the construction sketch from in the middle and create the turn-around chart. Notice how I worked on his outfit, too? Do this after you construct all three views. I also changed the pose around. This keeps it fun and less repetitive.

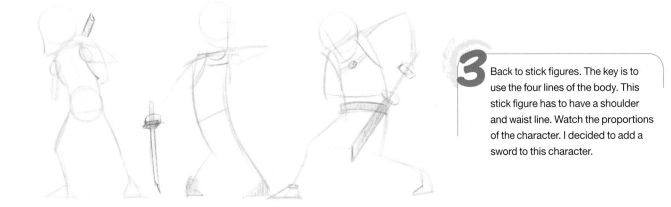

3 Back to stick figures. The key is to use the four lines of the body. This stick figure has to have a shoulder and waist line. Watch the proportions of the character. I decided to add a sword to this character.

Tip

A full turn-around chart would include front, front-3/4, side, back-3/4 and back views.

4 Sometimes, a stick figure will be so cool that you forget that it's supposed to be a stick figure. That's OK. The idea is to develop the character. If you are having fun, it's because you like what you are drawing.

5 On a clean sheet of paper, construct and draw a turn-around chart with final details. Sometimes an abbreviated turn-around chart is all you need.

 Trace a clean final drawing, then ink, scan and color.

On-the-Go Kid

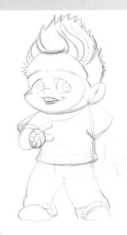

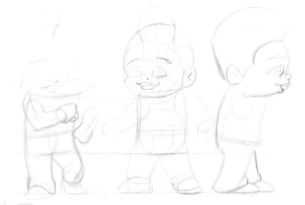

1 Go back to your sketchbook and find another head you like. Construct a body. Constructing makes it easier to draw the character in other views.

2 Create your turn-around chart. Use the basic shapes first. You can always add some finish details to your chart if you want to. Change the poses a little to keep it fun. In side view, you can leave off the near arm if you need to.

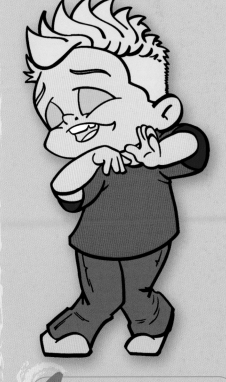

3 Test drive your cartoon out. Start with the stick figure. Watch your proportions. Once you have a page worth, construct over the top of them. After that, add the details. You will see your character begin to have life and personality very quickly at this stage.

4 Trace a clean final drawing, then ink, scan and color.

Sweet Girl

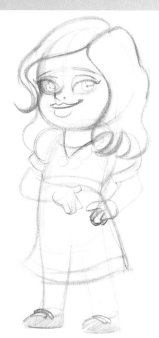

1 Here is another cartoon character. As you create new cartoons, you can also create two characters when you need just one. This girl was created at the same time the little boy was in the last demo. You can compare the two to each other as you create them. This helps you think about each feature as you draw it.

2 The next step is the turn-around chart. Feel free to experiment with the pose as you work up this chart. Start by figuring out the head heights and then add the basic shapes. Once this is done, add the details to the sketch. This can all be done on one sketch. The purpose is to help you learn to draw them. You do not need to show these to anyone.

3 Remember to pose the cartoon with your stick figure first. Watch your proportions. Then add your basic shapes.

Rough Is OK for Stick Figures

The purpose of the stick figure with basic shapes is to help you learn how to draw your character. It's not about drawing a great finished piece of art.

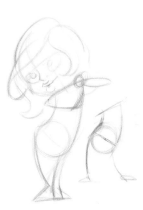

4 Continue with your stick figures until you fill a page in your sketchbook. Step 2 is to go back and add the shapes. Step 3 is to complete the art with your final details. This can all be done in your sketchbook.

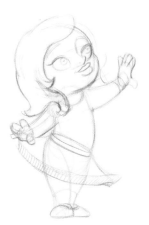

5 Once you decide on a final pose, go through the whole process to create it. Start with your stick figure first, and then add your shapes. Check your head height proportions next. Continue with the final details. Correct any mistakes.

6 Trace a clean final drawing, then ink, scan and color.

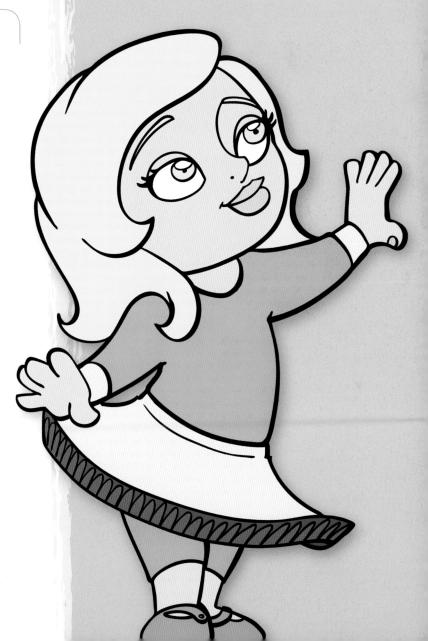

Businessman

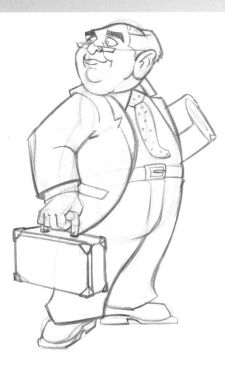

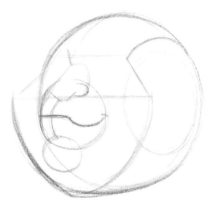

2 Start by figuring out the head shape. It is usually very helpful to establish the basic shapes, spacing and placing of the features.

1 In your sketchbook you can finish drawings as much as you want. You can come back later and revisit them to take them to the final color step. Here is one. It is not bad, but I have not completed any of the steps yet.

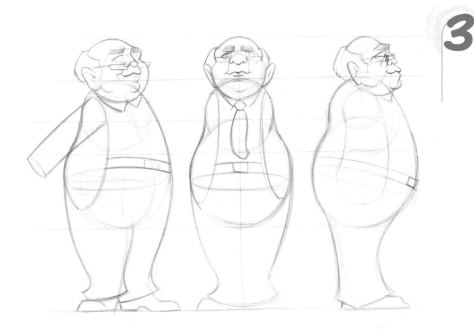

3 Continue your head shape and complete the turn-around chart as shapes first. You can also trace the head shape onto a new sheet of paper to better center the drawing. Here I flipped the head to make him looking in the other direction.

Look at your chart and decide what looks best. Sometimes you need to draw the whole chart and then figure out what your character will look like. This requires you do another chart to correct the mistakes.

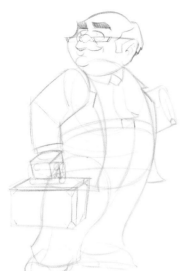

 4 Construct the final pose. For this cartoon, I used a circle for the rib cage and another overlapping circle for the waist and belly.

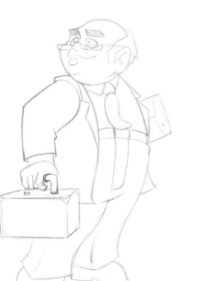

5 Clean up your drawing by drawing all the details on a new page.

6 Trace a clean final drawing, then ink, scan and color.

The Final Drawing

The final drawing should contain every line you plan to ink, and nothing else. It's easier to ink when you can focus on where to put the thicks and thins, without having to think about what you are drawing.

Pretty Lady

Remember

You draw because you enjoy it. Don't lose the joy.

1 Draw idea sketches. Let yourself return to old sketches and re-envision them. Each time I sketched this woman, she changed a little, and that's fine.

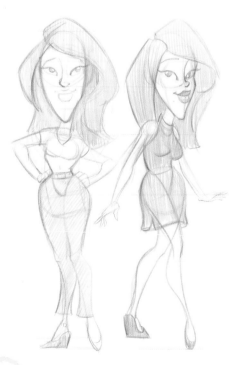

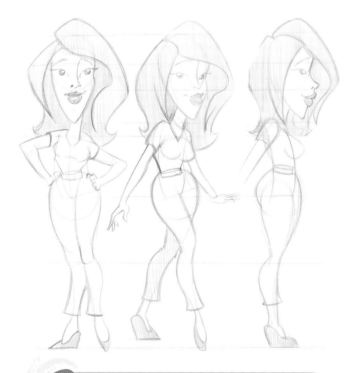

2 If you are unsure about facial features, try drawing the face smaller and adding a body. Drawing the face smaller forces you to simplify the features.

3 Once you know what the character looks like, create the turn-around chart to figure out the proportions.

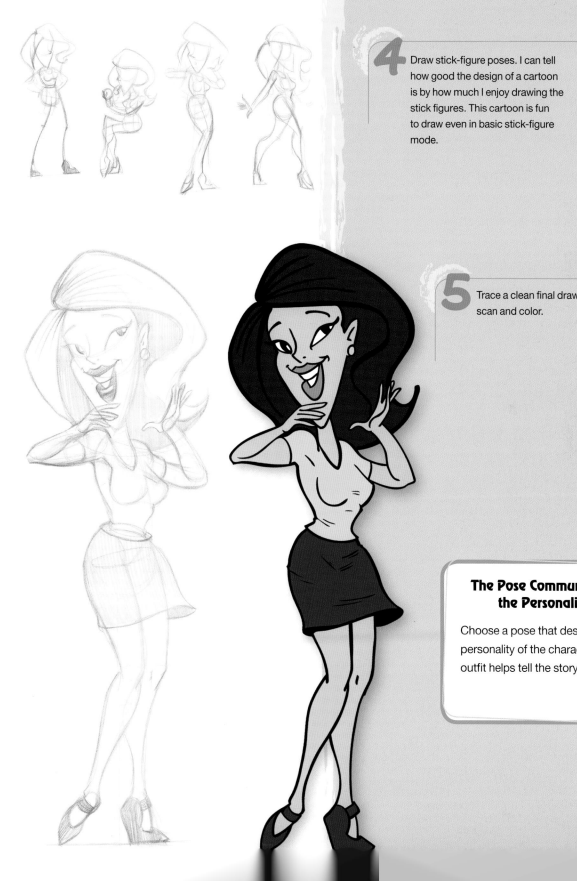

4 Draw stick-figure poses. I can tell how good the design of a cartoon is by how much I enjoy drawing the stick figures. This cartoon is fun to draw even in basic stick-figure mode.

5 Trace a clean final drawing, then ink, scan and color.

The Pose Communicates the Personality

Choose a pose that describes the personality of the character. The outfit helps tell the story, too.

Conclusion

Congratulations! You now have all my secrets for drawing cartoons in 3-D. Here is a quick review of the key points I made:

- Ideas should come from life. Draw a lot by going out and sketching in your sketchbook.
- Always have a sketchbook.
- Read this book from the beginning to get the most out of it. Don't skip steps that seem boring.
- Create a head shape sketch and figure out the spacing and placing of the features.
- Figure out how many head heights your cartoon is.
- Figure out what shapes you used to create your cartoon.
- Posing the cartoon is just as important as the cartoon itself.
- Clean up all your final details by tracing them onto a new sheet of paper.
- Before you start inking, do a dry run using pencil.
- Ink your drawing several times until you like the results.
- Color your artwork with as much detail as you want.
- Have fun drawing!

This book is an introduction to the professional world of cartooning. There is much more to learn about these concepts. My book *Cartoonimals: How to Draw Amazing Cartoon Animals* contains some additional detail and advanced techniques. The steps are the same whether you draw people, animals, cars, houses . . .

If you want to learn a lot about drawing faces, you should learn the art of caricatures. My book *Face Off: How to Draw Amazing Caricatures & Comic Portraits* teaches the secrets of drawing faces. Those secrets can be applied to all types of cartoons.

You can visit my blog at http://tutorialsbyharry .blogspot.com, where I have short examples and videos about many of the secrets in this book. You will also find a link to where you can post your cartoons for me to see.

Have fun for now and keep on drawing. Keep your eye out for more cartooning books!

Harry Hamernik

INDEX

Ideas. Instruction. Inspiration.

Harry Hamernik's first book, *Face Off*, is the authoritative guide to the art of comic portrait drawing. Easy-to-learn techniques and 30 step-by-step demonstrations make drawing caricatures fun and easy. You'll learn to draw specific features for the front, 3/4, and profile views, as well as how to color your art.

ISBN 13: 978-1-58180-759-2
ISBN 10: 1-58180-759-7
PAPERBACK. 128 pages. #33426

Cartoonimals by Harry Hamernik makes drawing animal characters easy and fun. Over 45 step-by-step demonstrations will help you learn to draw a variety of cartoon characters. Expert advice on everything from sketching to finding the right pose will help bring your original creations to life.

ISBN 13: 978-1-60061-114-8
ISBN 10: 1-60061-114-1
PAPERBACK. 128 pages. #Z2121

From facial expressions to creative coloring, *Draw Furries* contains all the know-how you need to create anthropomorphic cat, dog, horse, rodent and bird characters. With 38 step-by-step demonstrstions, Jared Hodges and Lindsay Cibos help you create a world of characters just waiting to burst out of your imagination.

ISBN 13: 978-1-60061-417-0
ISBN 10: 1-60061-417-5
PAPERBACK. 128 pages. #Z3838

These and other fine IMPACT products are available at your favorite art & craft retailer, bookstore or online supplier. Visit our website at www.impact-books.com.

IMPACT-Books.com

- Connect with other artists

- Get the latest in comic, fantasy, and sci-fi art

- Special deals on your favorite artists

- FREE projects and demonstrations when you sign up for the IMPACT e-newsletter